IMAGES
of America

ROCKFORD

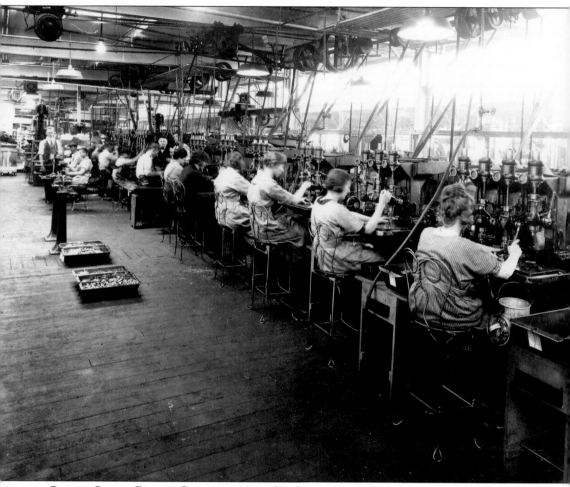

ON THE COVER: BARBER-COLMAN, 1920S. On the cover is one of the machine and small tools assembly areas in the vast Barber-Colman factory. Note the number of female workers on the assembly line. Barber-Colman's rapid growth from a small machine shop and experimental lab to a global corporation resulted in a several-blocks-long Rock Street plant with more than 1,000 employees. (Courtesy of Midway Village Museum.)

IMAGES
of America

ROCKFORD

Don Swanson

ARCADIA
PUBLISHING

Published by Arcadia Publishing
Charleston, South Carolina

Printed in the United States of America

Library of Congress Control Number: 2012933457

For all general information, please contact Arcadia Publishing:
Telephone 843-853-2070
Fax 843-853-0044
E-mail sales@arcadiapublishing.com
For customer service and orders:
Toll-Free 1-888-313-2665

Visit us on the Internet at www.arcadiapublishing.com

*This book is dedicated to the people of Rockford who are concerned
that we preserve our local history and especially to the staff and
volunteers at Midway Village Museum who make history come alive.*

CONTENTS

ACKNOWLEDGMENTS

Writing a pictorial history relating the entire history of a city like Rockford is a daunting task. I called on many friends to help me in assembling photographs for this book. I am especially grateful to Laura Furman and Regina Gorham in the collections department who painstakingly edited the text, and to David Byrnes, Midway Village Museum president, for his encouragement. Their assistance in finding photographs made the book a reality.

I am grateful to the education staff of Midway Village Museum for their continuing support providing materials and advice for the book. Lydia Cassinelli and Mark Herman were great sources of inspiration for undertaking this task.

Another friend and fellow Midway Museum board member, Suzanne Crandall, shared photographs and stories of her family. Through her rare photographs, I was able to have a better idea of historical life on the farms outside of Rockford.

Another friend, Jean Lythgoe, librarian of the Local History Room of the Rockford Public Library, was one of the first people I contacted when I began this project. Jean, who is president of the Rockford Historical Society, walked me through the rules for copyright and helped me find some rare pictures.

I greatly appreciate the support of the *Rockford Register Star* and GateHouse Media Holdings for their support in this project and for permitting the use of photographs from the *Rockford Register* and the *Rockford Gazette*. *Register Star* archivist Elnora Smith was very helpful in securing permission to use newspaper photographs. When I needed help finding background material on Rockford as a "forest city," I called on my friend Webbs Norman, the retired longtime director of the Rockford Park District. Meeting me periodically for breakfast, he took time to help me find photographs of the Rockford Park District of the past.

In the middle of the project, I was grateful to have the help of Guy Fiorenza, a local circus and music buff, for his help finding photographs of circuses in Rockford and Rockford's Harlem Park as well as historical postcards of Rockford.

I also received help from a former science teacher friend, John Ihne, finding photographs of Rockford industry in the 1940s and 1950s. His family collection helped me see the cooperative spirit present in Rockford industries for many years.

I am also grateful to my friend Bob Anderson, a former graphic arts teacher who taught in China after he retired from Rockford schools. Bob, who is 90, shared his wonderful collection of professional-quality historical photographs.

Lastly, I am very grateful to my sweet and patient wife, Caroline, who encouraged me daily in this effort. She gave her support and suggestions freely and helped me coalesce the ideas I wanted to highlight in the book. She also used her teacher skills to edit the text and make corrections of all kinds. I could not have finished the task without her.

INTRODUCTION

My interest in Rockford history began when I was a young principal at P.R. Walker School in Rockford. As I explored the school and the history of the building and its namesake, I became fascinated by the old photographs and diaries of Lt. Peleg R. Walker. Through his words, I discovered a whole new perspective of the Civil War and fascinating facts about the founding of the Rockford Public School System. Walker was Rockford's first superintendent of schools, but he died three weeks after attending the opening dedication of Walker School in 1912. Each Memorial Day, students from Walker School visited nearby Greenwood Cemetery to place flowers on Walker's grave.

During my time at Walker, many classes continued visiting his grave. One day in early May, I decided to visit Greenwood Cemetery by myself. In my visit, I also found the graves of many other Rockford founders and pioneers I knew from my limited knowledge of Rockford history. That visit sparked an interest in Rockford history, which has continued through the writing of the book.

Over the years, I gathered postcards, historical documents, and photographs of Rockford history and shared them with Rockford history teachers. My continuing interest led me to become active in projects at Midway Village, the local repository for artifacts related to Rockford history. Its uniqueness as a local history source has encouraged me to share its passion for the city's history.

The story of Rockford presented here is the story of the pioneering and adventuresome individuals who combined a spirit of curiosity and innovation in the search for an improved life for themselves and their families. The materials in the book were developed with extensive help from Midway Village Museum artifact resources and the staff. Items from my personal collection of over 3,000 photographs and postcards of Rockford history also makes up a large number of the images in this book.

The first sections describe Rockford's initial settlement in 1834–1835 by the risk-taking settlers Germanicus Kent, Thatcher Blake, and Lewis Lemon—a slave of Germanicus Kent's who later purchased his freedom. They arrived at the Rock River after traveling from Galena by "democrat"—a light flatbed wagon with two or more seats— wagon, and canoe. Through their efforts and those of other Rockford pioneers, Rockford was small city of nearly 7,000 by 1860.

The region around Rockford rapidly expanded as an agricultural powerhouse of the Midwest, and farmers were looking for machines to lighten their load in planting and harvesting their crops. This provided an inviting market for mechanical tinkers to tap into. As waterpower and rail transportation became readily available, penniless Swedish immigrants rose to be wealthy residents through the establishment of 82 furniture factories from 1870 to the 1930s. One such resident, P.A. Peterson, owned 27 of those factories in 1893. Several other industrialists turned inventions into multimillion-dollar enterprises, and Rockford became a well-known manufacturing site for machines and aeronautics.

One

Rockford's
Pioneer Founders

Many early settlers came to the village on the Rock River in poverty and made fortunes in a booming manufacturing community. The Rockford area, located 715 feet above sea level along the scenic Rock River and its major tributaries—the Kishwaukee, Pecatonica, and Sugar Rivers—was initially known as Midway because it was established at a ford halfway between Chicago and Galena.

In 1832, disgruntled over the loss of tribal lands, Winnebago chief Black Hawk began to attack white settlers in the area. A militia was raised and attacked Black Hawk and his small band of warriors. He and his Indian army were chased north along the Rock River into Wisconsin. On August 27, 1832, Black Hawk and his starving band surrendered to the settler militias.

With Black Hawk's defeat, the Rock River Valley was a prime site for early entrepreneurs. Germanicus Kent was born in Suffield, Connecticut, on May 31, 1790, acquired a practical business education, and for some years was engaged in prosperous business pursuits in Virginia and Alabama. Thatcher Blake was born in Oxford County, Maine, on March 16, 1809, where he resided until 1834. He too was drawn to an idea of achieving great financial success by striking out for the former Northwest Territory, beginning an arduous trip taking many months. Kent and Blake became acquainted, and in a Galena tavern, Germanicus talked enthusiastically about an exploratory trip to the Rock River Valley.

Daniel Shaw Haight, the first settler on the east side of Rock River, came from Bolton in Warren County, New York, and originally had made a claim near Geneva but sold it and moved to an even more promising site near the Rock River. On April 9, 1835, Haight, accompanied by his wife, Mary, her sister Miss Carey, and several others, arrived on the east bank of the river, looking for a desirable location for settlement.

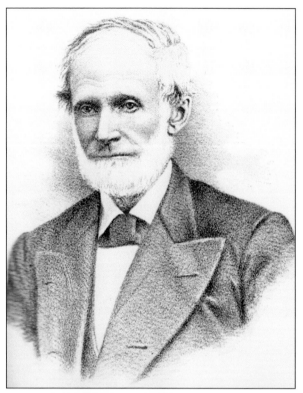

ROCKFORD FOUNDERS. In the early spring of 1834, Germanicus Kent, Thatcher Blake (pictured), and Lewis Lemon set out with a helper on an exploratory trip across the prairie grass and unbroken forests. They established their claims on the banks of Rock River, initially naming the new community Midway because it was halfway between Chicago and Galena. Two years later, the name was changed to Rockford. (Courtesy of Rockford Library.)

NEW SALEM STATE PARK REPLICA OF AN 1834 LOG CABIN. The 18-by-24-foot home originally built by Daniel Haight on Rockford's east side in 1835 was much like the one shown. The cabin was built for Daniel, his wife, Mary, and her sister, Miss Carey. The loft of the cabin served as sleeping quarters. The Haights also used the first floor area for sleeping. (Author's collection.)

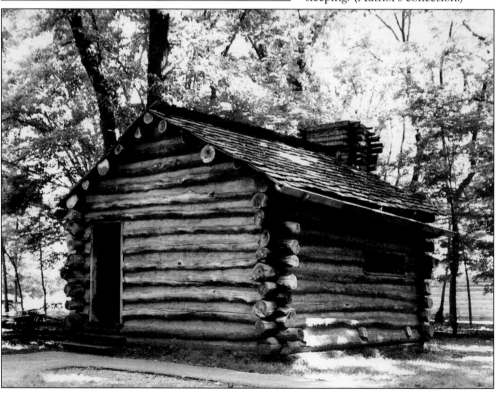

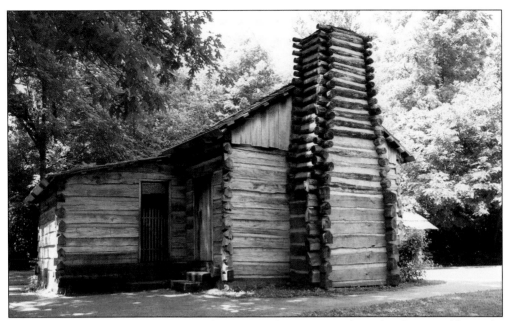

PETER LUKIN RESIDENCE. Constructed in New Salem in 1831, this cabin has an addition for a leather shop. Many early craftsmen settlers built shops alongside their homes. By 1837, there were 58 buildings similar to the one pictured for tailors, blacksmiths, leather workers, hardware merchants, saloon keepers, and hotel owners in Rockford, many of which were connected to homes. (Author's collection.)

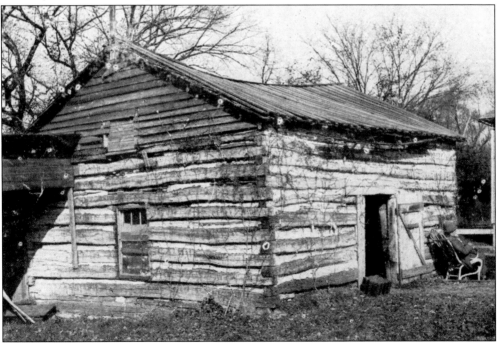

SHEPARD LEACH LOG CABIN, 1837. David S. Penfield and Shepard Leach came to Rockford from Michigan, purchasing large tracts of land and becoming general store merchants. Leach's cabin is seen here in 1905, when it was being used as a shed. (Courtesy of Midway Village Museum.)

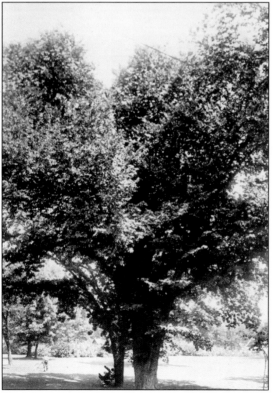

ROCKFORD'S FIRST BANK, 1844–1855. In the 1840s, Rockford was led by settlers like John Holland and Thomas D. Robertson, who concentrated their efforts in banking and real estate. Their bank was on the 300 block of East State Street, and they also led the village in building a courthouse and lobbying for a Chicago, Rockford, and Galena Railroad. (Courtesy of Rockford Public Library.)

MANDEVILLE ELM. The famous Mandeville Elm in Mandeville Park is seen here in 1914. At the time, Robert Tinker said that the tree was 168 years old, having been planted in 1746. The care early settlers took in preserving it was typical of their "forest city" spirit. (Courtesy of Rockford Park District.)

THE "ROCKY FORD" MARKER. A Rockford resident is examining the marker that was placed by the site of the original rocky bottom ford of the Rock River, located at the end of Pine Street in downtown Rockford. Due to its characteristics, the ford retains its pioneer name, Rocky Ford. The memorial was placed here in 1964 to commemorate the beginning of Rockford in 1835–1836.. (Courtesy of Midway Village Museum/Jon Lundeen.)

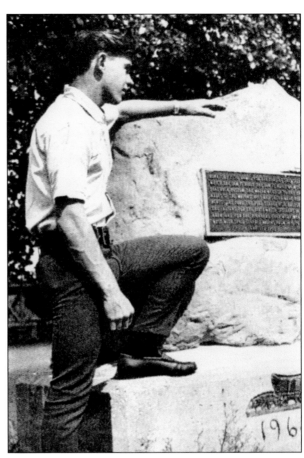

BLACKHAWK PARK LOG CABIN, 1914. The Blackhawk Park was a re-creation of the type of cabin Germanicus Kent and others constructed from 1836 through 1839. The settler's original homes were hastily constructed from materials found in the wooded areas near the Rock River. (Courtesy of Rockford Park District.)

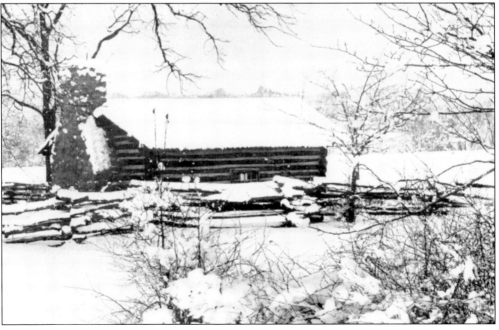

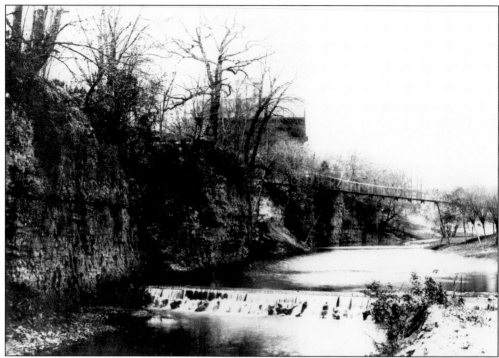

DAM ON KENT CREEK. Construction of Germanicus Kent's dam and sawmill on Kent Creek began in the late summer of 1834. Kent returned the following summer with his family to find that the dam had been washed away by spring floods. He rebuilt the dam and completed the mill. He also built the log cabin for his family. (Courtesy of Midway Village Museum.)

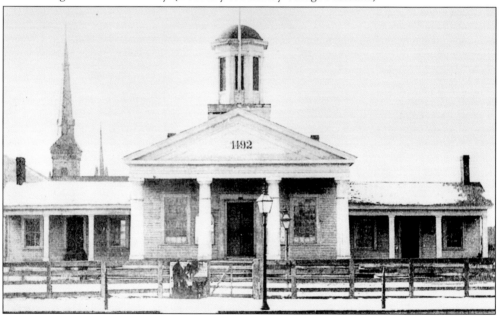

LATE 1850s COURTHOUSE. This unidentified photograph may be of one of the first hotels, the Winnebago House, built on Rockford's west side in the 1840s. Close to the banks of the Rock River, it was the first brick building in Rockford. (Courtesy of Midway Village Museum.)

Two

ROCKFORD'S
WATERPOWER

In 1846, a group of Rockford citizens attempted to build a gravel-and-brush dam across the Rock River near present-day Beattie Park and the Jefferson Street Bridge. The dam was washed out in a spring flood in 1851 and, using an 1849 act of the Illinois legislature, a group of businessmen headed by Thomas Robertson and John Holland organized to build a limestone dam on the original rock-bottomed ford. The waterpower district was along the west side of the river for a quarter of a mile below the dam. Although the area is now largely abandoned, it was here that Rockford industry had its start. At one time, the millrace was divided into 17 channels over which numerous factories generated power. The first sawmills, flour mills, textile mills, machine shops, and agricultural implement factories in Rockford were based on this waterpower, the impetus for Rockford industry for nearly a century. Here was incubated the infant progeny "agricultural machine manufacturing," which grew by leaps and bounds with the establishment of manufacturing companies like Emerson and Talcott in 1852, N.C. Thompson, Briggs and Enoch, William A. Knowlton, John P. Manny, Rhoades, and Utter.

From this small area, numerous companies—which later became the city's largest machine, metalworking, and tool factories—started in small buildings only to outgrow the limited capacities and move to other parts of town, mostly in the area close to the waterpower district and rail centers. In no other part of Rockford were factories constructed so close together; they were mostly built right next to one another. Some of the factory buildings are now almost 150 years old, but with the abandonment of waterpower usage in the 1950s, the millrace was filled in with cinders and dirt, producing building sites for more factories. The companies in the waterpower district are now mostly small metal-fabricating plants.

EARLIEST ROCKFORD PHOTOGRAPH, 1853. The first photograph of Rockford, taken from above State Street on the east side of the river, shows the ramshackle bridge built by Deratus Harper in 1844. In 1851, when Rockford's original dam broke, the bridge's west side embankment was torn away. The bridge was put back in place with citizens using a block and tackle arrangement. (Courtesy of *Register Star*.)

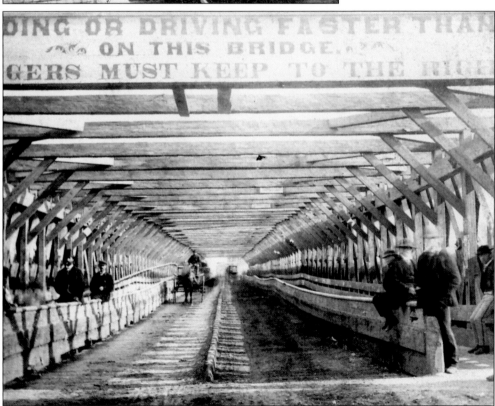

ROCKFORD'S SECOND BRIDGE, 1854. In 1853, the Illinois legislature gave the city council permission to borrow the necessary funds to replace the rickety 1844 bridge. The newly constructed bridge had walkways on both sides for pedestrians, two lanes to allow wagons to pass two abreast, and was covered to provide protection against rain and snow. (Courtesy of *Register Star*.)

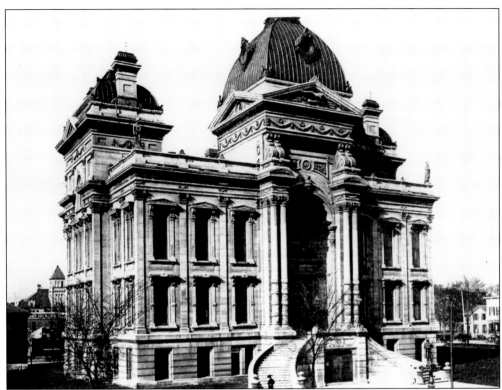

WINNEBAGO COURTHOUSE, 1880S. Rockford's first courthouse was constructed in 1844 by the builder of the first bridge, Deratus Harper, and John Beattie, a carpenter. Henry Thurston describes the structure, on the west end of the present courthouse square, as a single-story building with an imposing facade. The date *1492* was said to have been placed on it to recognize the landing of Christopher Columbus. The 1876 courthouse (pictured) was considered to be of French Venetian style. The foundation walls are sunk seven feet six inches below the grade line and rest on six-foot-wide limestone footing courses. The reinforced basement, with 24-inch-thick walls, was needed to support the dome, which fell during the original construction in 1877. (Courtesy of Midway Village Museum.)

WINNEBAGO COUNTY COURTHOUSE, 2010. This seven-story tower was constructed in 1966–1967 to house all Winnebago County governmental functions. In 1977, a public safety annex was constructed to serve the sheriff and the Rockford Police Department. Since that time, most of the administrative functions have moved to the County Administrative Building at 404 Elm Street. Presently, this building houses county court functions and the police department. (Author's collection.)

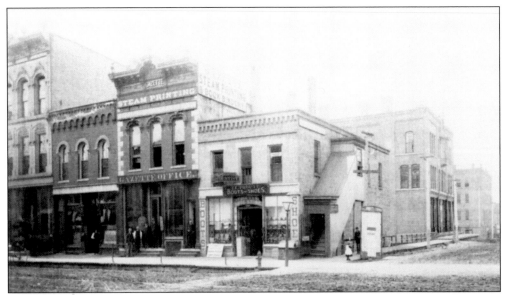

WEST STATE AND WYMAN STREETS, 1870s. This photograph illustrates the changes taking place in the city's commercial center. Older stores had plain, unadorned clapboard fronts. To the right are an early shoe store and the office of the *Rockford Gazette*, while farther to the left is a more substantial brick, Federal-style building. Note the wooden sidewalks, high curbing, and unpaved main streets. (Courtesy of Rockford Public Library/F.C. Pierce.)

THE WATERPOWER DISTRICT, 1972. By this time, only a few large factories remained in the Waterpower area. One of the race outlets can still be seen from the river. (Courtesy of Midway Village Museum.)

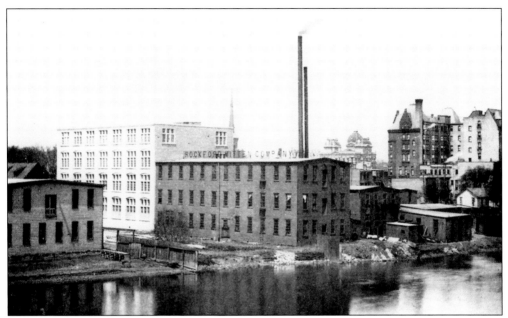

RAIL BRIDGE VIEW OF WATERPOWER DISTRICT, 1880s. The Rockford Mitten Company was founded in 1879 by John Nelson and William Talcott. In 1885, William Ziock, a Missouri textile manufacturer, agreed to a merger with the Nelsons, and the new company became the Rockford Mitten and Hosiery Company, with the manufacture of hosiery being its primary business. (Courtesy of Midway Village Museum.)

100 YEARS LATER. In the 20th century, Rockford's industries expanded by leaps and bounds, due in large part to innovative ideas from business leaders. With the demise of American heavy industries in the 1990s, Rockford manufacturing entered a decline, but today, new industries are again developing. (Courtesy of Midway Village Museum.)

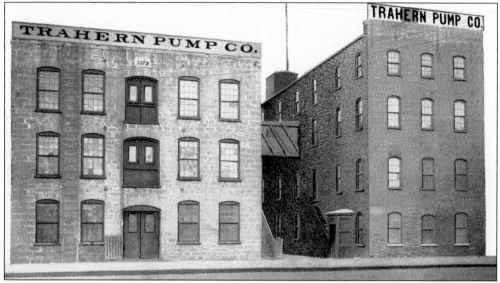

Trahern Pump Company, 1865. Trahern Pump, which built iron and brass pumps, was one of the original companies in the Waterpower area. This two-building factory was constructed in 1876 at the corner of Wyman and Mill Streets and employed 80 to 100 workers. (Courtesy of Rockford Public Library/F.C. Price.)

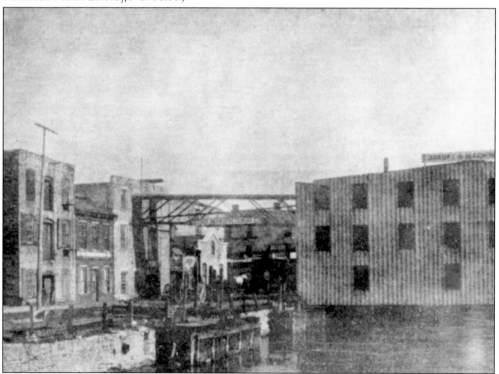

Utter Manufacturing Company, 1876. The Utter factory, located on both sides of Race Street in the Waterpower District, was another original waterpower user, established in 1846. The plant manufactured agricultural implements, and the buildings included a machine shop, a foundry, a pattern shop, and a blacksmith. (Courtesy of Midway Village Museum.)

Three

ROCKFORD'S AGRICULTURAL MECHANICS

Rockford's real origin as a city came with the formation of the Waterpower District. This triangular-shaped body of land, bounded by Kent Creek on the south, Rock River on the east, Northwestern Railway on the north, and Main Street on the west, was the birthplace of industrial Rockford. The chief industrial activity was the manufacture of agricultural implements by John H. Manny, Emerson Talcott, John P. Manny, N.C. Thompson, Briggs and Enoch, William Knowlton, Rockford Plow Co., and the Utter Manufacturing Co. Other early waterpower industries were the Trahern Pump Co., Graham Cotton Mill, Rhoades, Utter Manufacturing Co., Keeny Paper Mill Co., S.B. Hendricks Planing Mill, T.J. Derwent Co., Z.B. Sturtevant Flour Mill, Savage & Love, Rockford Tack Factory, Rodgers Galvanizing Works, Forbes Foundry, and S.W. Woodward.

Like many of Rockford's first manufacturers, John H. Manny assisted on the family farm and became familiar with all the duties and labors of a farmer. He continued to look for tools to make a farmer's job easier and, in his late teens, invented a mower/reaper worked under horsepower. In 1853, Manny manufactured 150 of his reapers. A year later, he manufactured 1,030, and in 1855, he had his reaper exhibited at the International Exposition in Paris. Napoleon III was so impressed with the machine that he purchased one. There was so much demand for his farm machines that it caused a labor shortage in Rockford. In the spring of 1854, he was joined by Orlando Clarke; two wealthy Rockford farmers, Wait and Sylvester Talcott; his cousin, John P. Manny; Jess Blinn; and Ralph Emerson, and J.H. Manny & Co. was founded. Between 1855 and 1856, the new company manufactured about 6,000 machines for harvest.

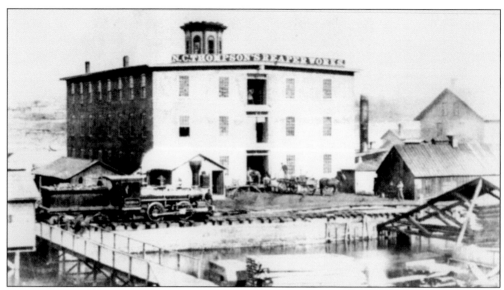

N.C. THOMPSON FACTORY, 1860S. The N.C. Thompson Co., a large producer of agricultural machines, began operations in the Waterpower District in 1859, becoming the primary producers of John H. Manny's reapers. Later, it became one of northern Illinois's and southern Wisconsin's largest producers of reapers, mowers, cultivators, and plows. Part of the large intake channel for waterpower is shown in the foreground. (Courtesy of Rockford Public Library/F.C. Price.)

MANNY'S REAPER AND MOWER. John and his father Pels, tinkered with two Easterly reapers, tearing these machines apart, and totally rebuilt them from the ground up using John's ideas. By 1852, when he was a 27, John H. Manny held several patents and was recognized as a gifted mechanic. His cousin John P. Manny invented a knife section for the Manny reaper and moved to Rockford to begin the manufacture of the machine. In 1852, John H. also moved to Rockford and worked with his cousin to mass produce Manny Reapers. (Courtesy of Tinker Swiss Cottage Museum.)

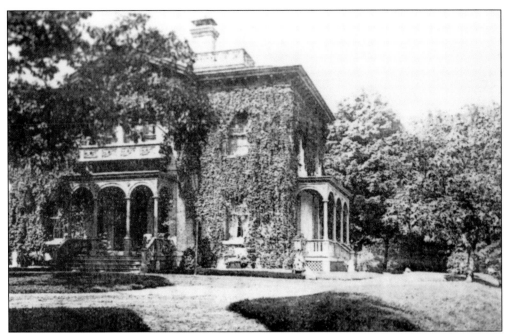

HOME OF JOHN H. AND MARY MANNY. John H. Manny built a palatial home close to the Waterpower District shortly before his death in 1856. He never had the opportunity to live in it. Manny, 30 years old, died of tuberculosis and "stomach trouble" in his original small home on South Main Street. The mansion became Mary Dorr Manny's home after John H.'s death. It was torn down in 1900. (Courtesy of Tinker Swiss Cottage Museum.)

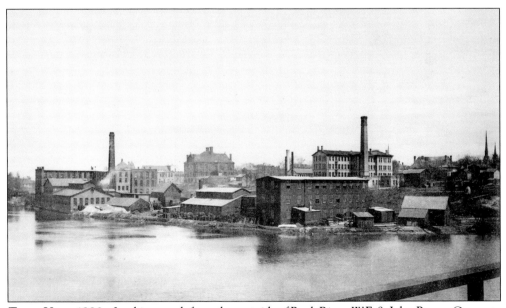

TRAIN VIEW, 1880s. Looking north from the east side of Rock River, W.F. & John Barnes Company is on the far left, and Rockford Watch Company is in the center right in the background. Rockford High School is the peaked building in the left background. The industries on the east side of the river depended on steam power in their early years. (Courtesy of Midway Village Museum.)

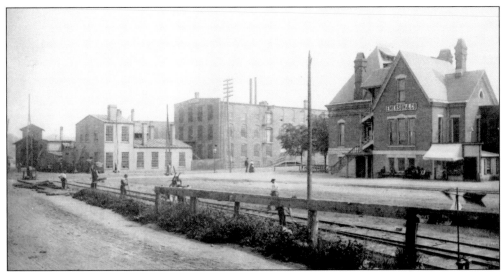

EMERSON AND TALCOTT COMPANY. In 1865, financier and business leader Ralph Emerson, the cousin of transcendentalist writer Ralph Waldo Emerson, joined the John H. Manny Reaper firm. After Manny's death, the company changed its name to Talcott, Emerson, and Company and continued to build on the 28 patents Manny had left. The name was later changed to the Emerson Manufacturing Company. (Courtesy of Rockford Public Library/F.C. Price.)

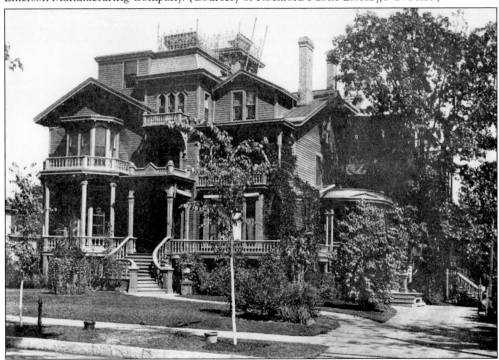

RALPH EMERSON HOME, 427 NORTH CHURCH STREET, 1890. Ralph Emerson lived here with his wife, Adeline Talcott, who was a daughter of a Manny Company partner Wait Talcott. The Emersons were important and influential personal factors in the development of social functions in and about Rockford. In their later years, they traveled extensively in other parts of the United States and to Europe. Ralph died on August 19, 1914. (Courtesy of Rockford Library/F.C. Price.)

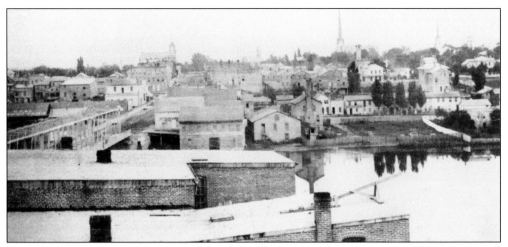

RIVER TOWN, 1870S. In this photograph, the population growth to the east is visible. Many small factories, lumberyards, and food supply warehouses were located close to the river. The prosperity of the agricultural manufacturers helped fuel Rockford's growth in other, related industries. (Courtesy of Midway Village Museum.)

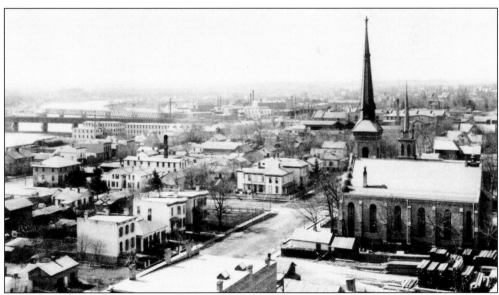

LOOKING SOUTH FROM COURTHOUSE, 1879. Rockford's population began to grow faster as people moved to town to work in these agricultural implement factories. (Courtesy of Midway Village Museum.)

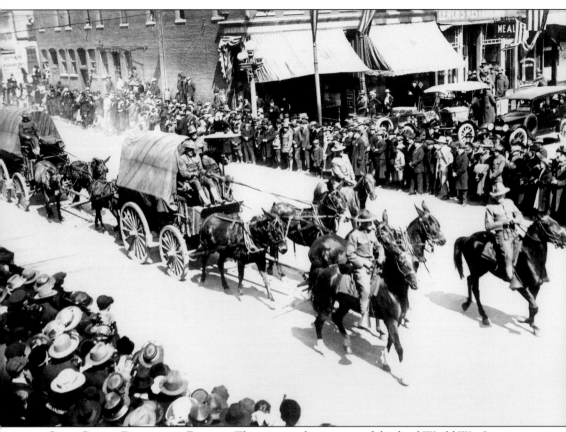

CAMP GRANT DOWNTOWN PARADE. This picture shows some of the final World War I regiments at Rockford's Camp Grant parading in a July 4, 1918, parade at the corner of State and Main Streets in Rockford. The camp was closed shortly after but reopened at the start of World War II. (Courtesy of Midway Village Museum.)

Four

ROCKFORD'S
FURNITURE BARONS

Located halfway between Chicago and Galena, Rockford grew to be the second-largest city in Illinois. The Rock River, the presence of a rail system, and the dense hardwood forests made the area around the city ideal for milling. In 1853, the *New York Tribune* nicknamed Rockford the "Forest City."

The Chicago and North Western Railway came to Rockford in 1852 and brought a dramatic increase in immigration of Northern Europeans, especially Swedes. Andrew C. Johnson, John Erlander, Jonas Peters, and P.A. Peterson were among the first. Johnson arrived in 1852, set up shop with some partners in the Waterpower District, and began manufacturing chairs and stools. In 1865, he joined in a partnership with Gust Hollem and John Nelson to make sashes, doors, and blinds. In 1872, Johnson formed a partnership with J.F. Anderson and hired Jonas Peters as a furniture maker and salesman. Erlander and Peterson also began cooperative furniture ventures in 1871.

Before long, Rockford's furniture industry was established. The craftsmanship of the Swedish immigrants involved carved wood accents and became very popular. The first boom of Rockford's furniture industry was in the early 1890s and ended with the economic crash of 1893. The most productive time for the industry was in the years following World War I. Several of the original companies remained from the 19th century, and many more opened. By 1925, there were more than 30 factories still making furniture in Rockford.

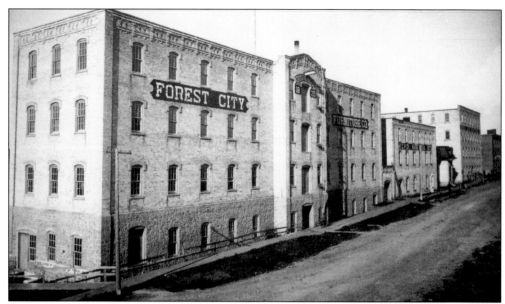

FOREST CITY FURNITURE, 1912. Established in 1869 by A.C. Johnson as Rockford's first furniture factory, Forest City Furniture built this plant in 1875. Officers were Gilbert Woodruff, president; Ralph Emerson, secretary and treasurer; and A.C. Johnson, superintendent. (Courtesy of Rockford Public Library/F.C. Price.)

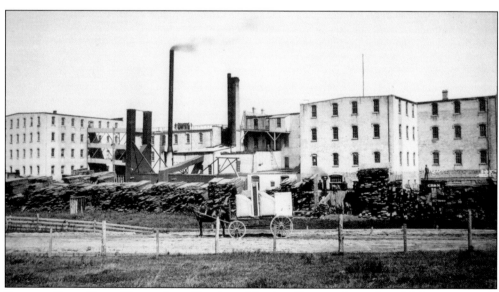

FACTORY REAR VIEW. These piles of hardwood lumber illustrate how plentiful furniture-grade wood was in the area. A.C. Johnson had the habit of cutting wages in order to meet expenses, and his company, the first in town, continued to be one of the largest. (Courtesy of Rockford Public Library/Horner.)

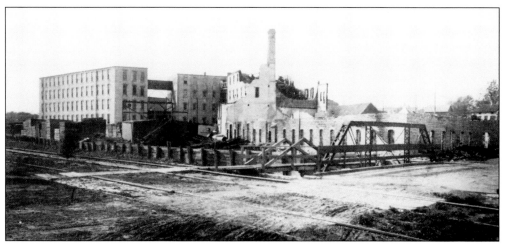

FOREST CITY FURNITURE FIRE, 1895. On April 29, 1895, Forest City Furniture had a major fire, but it was rebuilt and remained in business until the summer of 1919. The factory included four large four-story brick buildings, with a floor area of 150,000 square feet. The company also had six acres of yard room for lumber storage. The 240 workers produced a general line of furniture and office desks. (Courtesy of *Rockford Fire Department Fire Log*.)

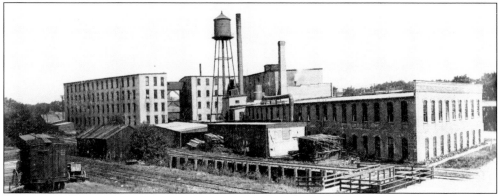

BRUNSWICK PHOTOGRAPHS, 1903. Investors purchased the defunct Forest City Furniture in March 1920 and began manufacturing Brunswick Phonographs. The company name, many of the workers, and most of the equipment came from Forest City Furniture. (Courtesy of Rockford Public Library/C. Daly.)

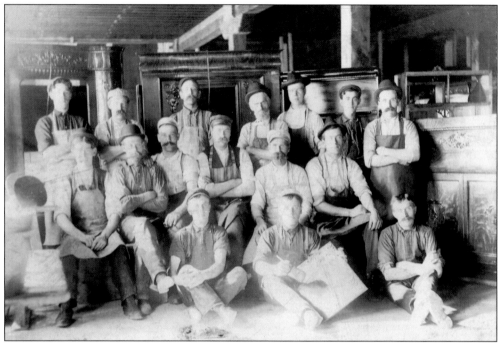

FOREST CITY FURNITURE EMPLOYEES, 1890S. Most of these workers were skilled craftsmen of Swedish descent who made most of the furniture entirely by hand. In 1897, the company had a gross income of more than $300,000 a year. (Courtesy of Midway Village Museum.)

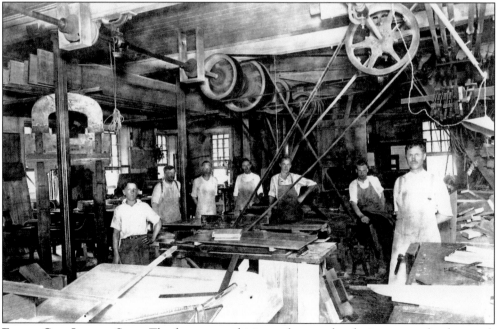

FOREST CITY JOINING SHOP. The factory wood joinery shop used techniques to make the wood, which has different properties along different dimensions, more uniform. The wood joints were fastened with glue, and pegs with nails were used when extra reinforcement was necessary. (Courtesy of Midway Village Museum.)

P.A. PETERSON. An entrepreneurial genius, Peterson was the guiding light of the Rockford furniture industry, helping dozens of companies achieve success. He started out as the Union bookkeeper, but he was soon forced to take over the management of its daily operations as well. Peterson eventually became president of many companies and, altogether, he owned stock in 50 Rockford enterprises. Though most of the factories are now closed, some of the present Rockford machine, tool, and aerospace businesses were started by P.A. Peterson. (Courtesy of Midway Village Museum.)

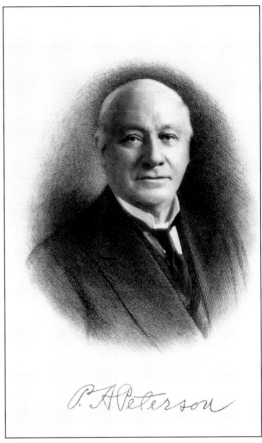

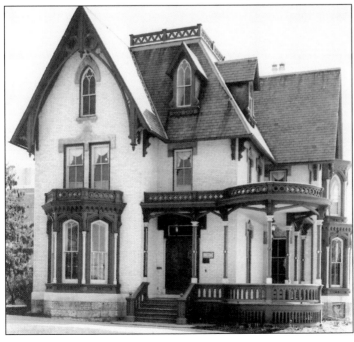

P.A. PETERSON HOME. In 1905, P.A. Peterson moved here, to 1313 East State Street, where he spent the later years of his life with his wife, Ida Mae, and two adopted daughters. Almost every day, Peterson walked several miles down State Street to his small office at Seventh Street and Eighteenth Avenue. (Author's collection.)

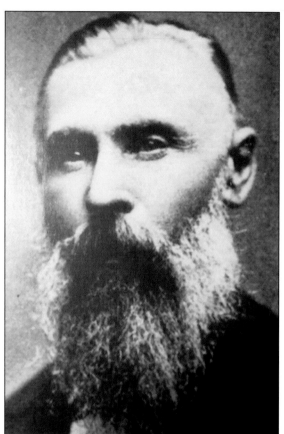

JOHN ERLANDER. John Erlander (1826–1917) was born in the province of Småland in southern Sweden and came to Rockford in 1855. Originally a tailor, he was in many businesses, most with Swedish partners and Swedish employees. The establishment of the Union Furniture Company was his most important accomplishment, and he was active in the company for the rest of his life. (Courtesy of Rockford Public Library.)

ERLANDER FAMILY AT HOME. In 1871, John Erlander, the first important Swedish businessman in Rockford, built this 14-room Italianate home at 404 South Third Street. It is now the museum of the Swedish Historical Society of Rockford, the local Swedish club. In 1875, in the living room of his home, Erlander held a meeting with P.A. Peterson, Jonas Peters, and James Sundquist to discuss forming a cooperative furniture company where the workers would own stock. (Author's collection.)

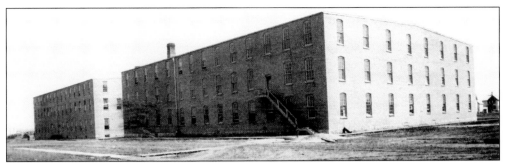

UNION FURNITURE COMPANY, 1905. In 1876, a group of Swedish cabinetmakers, dissatisfied with their jobs in America, met at John Erlander's home to form their own furniture factory, a cooperative. The men chose P.A. Peterson to be secretary of Union Furniture Company since he had taken a bookkeeping course. (Courtesy of Rockford Public Library/F.C. Price.)

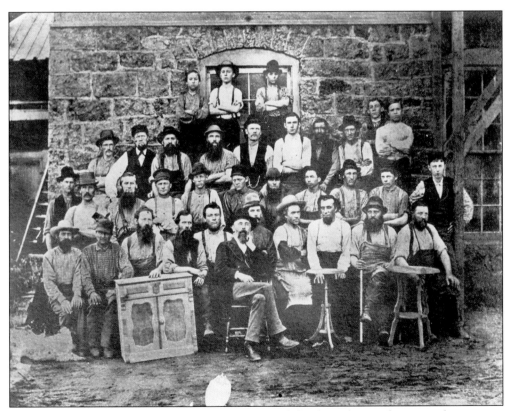

UNION FURNITURE WORKERS, 1880S. The work was difficult, with most factory workers staying on the factory floor for 12 or more hours. In 1892–1893, during a national financial panic, most of the company's 140 employees were temporarily laid off in order to save the firm from bankruptcy. (Courtesy of Midway Village Museum.)

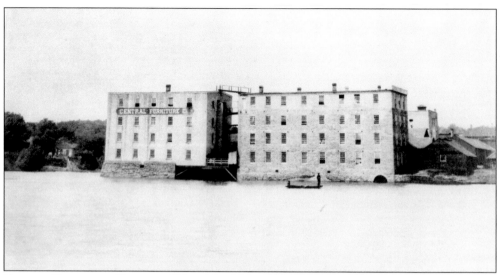

CENTRAL FURNITURE COMPANY. When John Nelson's old planing mill in the Waterpower District was destroyed by fire, a much larger structure, emulating the Forest City Furniture facility, was built on the site. In 1879, the building became the Central Furniture Company, incorporated by P.A. Peterson and 46 Swedish workers/shareholders, who contributed $500 each to help finance the construction. (Courtesy of Midway Village Museum.)

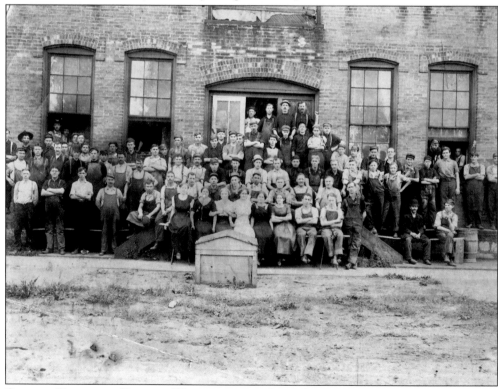

CENTRAL FURNITURE FACTORY WORKERS, 1908. Central Furniture manufactured bookcases, desks, and extension tables, and estimated its annual output at $150,000. It employed 140 hands with an annual payroll of $75,000. (Courtesy of Midway Village Museum.)

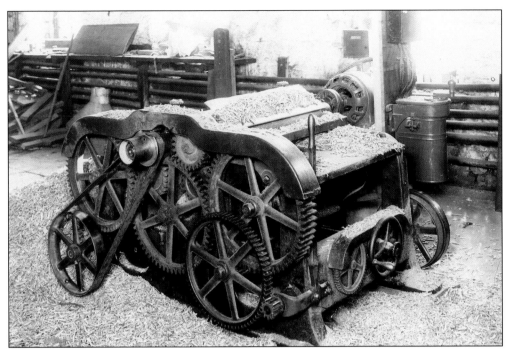

CENTRAL FURNITURE PLANING MACHINE, 1907. This planing machine has horizontal and vertical cutters. The lumber was fed into the machine by feed rollers on each side of the top cutter block to eliminate the risk of splitting. (Courtesy of Midway Village Museum.)

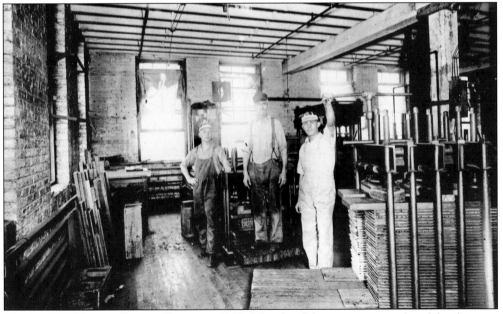

WORKERS AT VENEER GLUING STATION, 1903. Most local furniture was produced for the mass market and middle-income consumer-based prices. Sales were so strong that it supplied a base for creative designers and business people to try new ideas. The furniture manufacturers were the reason many supporting businesses opened in the Rockford area. (Courtesy of Midway Village Museum.)

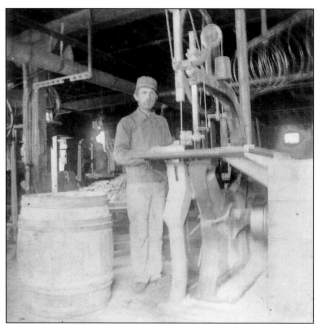

ROCKFORD CABINET VENEER GLUING STATION, 1903. Nels Anderson works the veneer gluing station at Rockford Cabinet, which was established in 1894 and run by the same cooperative that controlled Central Furniture. Rockford specialized in the production of dining room, library, and bedroom furniture. It also manufactured high-quality wood mantles for fireplaces. (Courtesy of Midway Village Museum.)

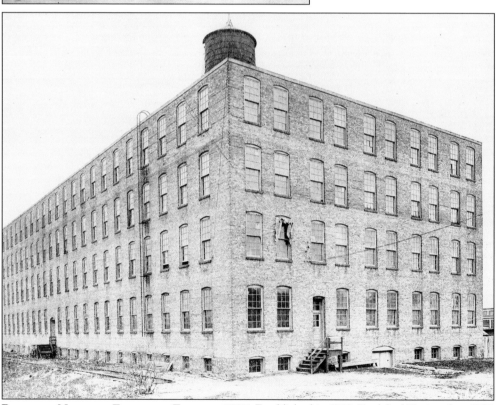

ROCKFORD NATIONAL FURNITURE FACTORY, 1907. Established in 1907, Rockford National, at 2300 Kishwaukee Street, remained in business until the late 1920s. August Peterson was president of the company, and P.A. Peterson was treasurer. The factory logo can still be seen on the building, which is located on Kishwaukee Street. (Courtesy of Rockford Public Library/C. Daly.)

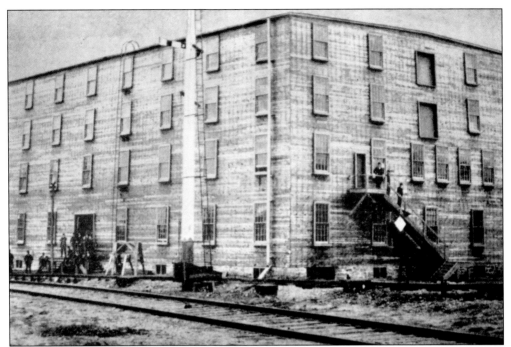

MECHANICS FURNITURE COMPANY, 1890. Mechanics Furniture Company was organized with the help of Jonas Peters, a Chicago furniture salesman who lost his job after the Great Chicago Fire of 1871. Peters served as secretary from Mechanics' incorporation until his death. Peters's hard work and sacrifice prevented Mechanics from going into the hands of the receivers in the panic years of 1892–1894. (Courtesy of Rockford Public Library/F.C. Price.)

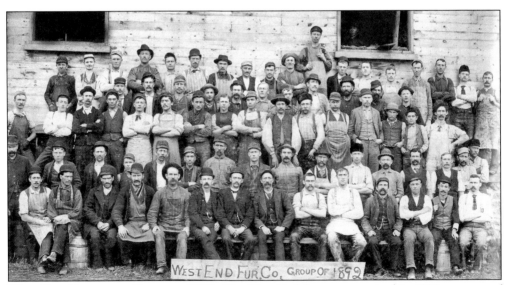

WEST END FURNITURE FACTORY, 1890. The West End factory, organized in 1890, was one of the few furniture manufacturers not of Swedish descent. It employed about 150 men, making bookcases, desks, tables, and chiffoniers. The five-story plant was one of the few made of brick. (Courtesy of Midway Village Museum.)

ROCKFORD COOPERATIVE FURNITURE. In 1879, a group of Swedish craftsmen and investors opened Rockford Cooperative with $100,000 in capital. The company officers were Alfred Larson, E.C. Jacobson, and C.J. Lundberg. Their 125 employees produced an annual output of more than $200,000. The building was typical of most factories: four stories with a flat roof and monotonous rows of windows. (Courtesy of *Rockford Today*, 1904, published by Register Star.)

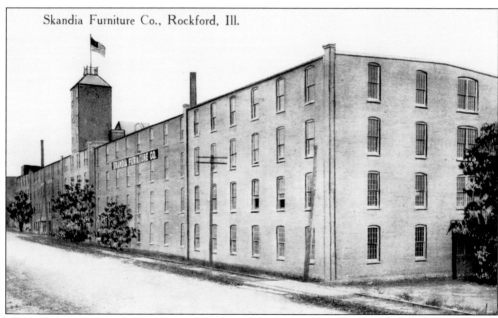

SKANDIA FURNITURE, 1935. Located at 1202 North Second Street, Skandia once ranked as Rockford's largest furniture manufacturer, producing a variety of products including Viking-brand bookcases, hall trees, cylinder desks, secretaries, and pillar extensions. The president, Horace Brown, lived in the neighborhood east of the plant. Skandia was in business from 1889 to 1941 and built this two-block-long riverfront plant in 1890. (Author's collection.)

Five

FROM PIONEER TOWN TO MACHINE CITY

Due to the efforts of the Rockford business community to make Rockford a regional industrial center, the city grew from a quiet pioneer village of 7,000 in 1860 to a city of more than 20,000 only 20 years later. The reasons for the tremendous growth of the city go beyond its powerful industrial base. The vivaciousness of the development of many city's commercial centers can be seen in photographs from around 1900. They indicate a substantial foundation in strong and solvent business operations. The city's offerings in the way of ethnic culture celebrations, a deep commitment to religious faith, a dedication to educational advantages, and social and fraternal clubs made Rockford a magnet for many ethnic immigrants. Different groups not only assimilated American values but made a real effort to celebrate traditions of their native lands.

By 1920, sixty-two percent of residents owned their own homes, indicating a well-paid workforce. Until the 1920s, it was common to pay cash for a home instead of getting a bank loan. Most family homes were two-story frame dwellings with four to six rooms, and while only a small number of houses were large, almost all were a far cry from the one-room log cabins erected by Germanicus Kent and Thatcher Blake.

Surveying the surrounding countryside, a visitor would find rolling farmland with rich and black soil, adapted for grain and stock. During the city's great expansion between 1880 and 1920, a total of 80 different kinds of manufacturing firms were included among the 224 institutions in Rockford. The factories employed more people, who were all receiving more money than ever before—a big change from the Rockford pioneers who barely survived the winters of 1834 and 1835.

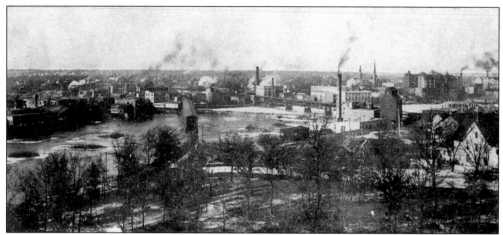

From Rockford College towards Waterpower District. By the 1870s, Rockford was fully involved in a variety of diversified industries. The bridges of Rockford's two original railways, the Chicago and North Western and the Illinois Central, are in the center of this photograph. In the right foreground, the Rock River dam and power company is on the east bank. The Waterpower District was completely developed and, by this time, many of the companies had either electrified or switched to steam power to more efficiently power their machines. (Courtesy of Rockford Public Library/Horner.)

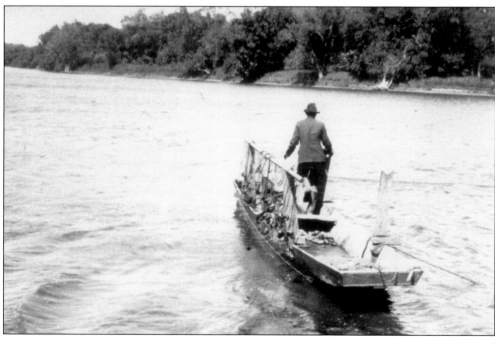

Rock River Clamming. From the 1870s to 1900, harvesting clams from Rock River was a big industry. The meat was removed and sold as pig feed or fish bait and, after inspection for pearls, the shells were piled on the riverbank, where they remained until the shell buyers made their rounds. Prices for clamshells peaked at $110 per ton, but by 1935, the price had dropped to just $30 per ton. (Courtesy of Rockford Park District.)

BELOIT ROAD. By 1915, the area to the left was made into Sinnissippi Park. At 1600 North Second Street, it contained 123 acres, including a golf course, a lagoon, and picnic areas. North Second Street is a two-lane gravel road in this image; it is now a four-lane divided highway. (Courtesy of Rockford Park District.)

E.A. NELSON HOME. E.A. Nelson was a sporting goods merchant who had a large store in the Seventh Street business district. Earlier, he had run two confectionary stores and a grocery store. His Seminary Street home contained many varieties of flowers and decorative plants. (Courtesy of Rockford Public Library/Horner.)

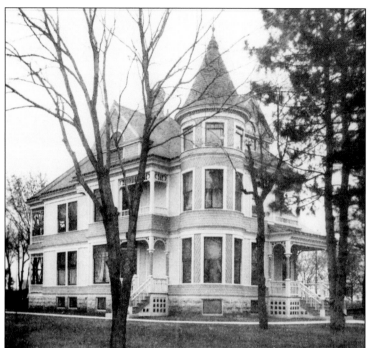

L.M. Noling Home. When he first came to America from Sweden, L.M. Noling went to work designing new equipment for John Nelson. Later, he invested in several Rockford businesses, including Mechanics Furniture Company. In 1892, Noling became an Illinois state representative and in 1893, he built this Victorian home on a plot surrounded by a large variety of trees at 1508 Kishwaukee Street. (Courtesy of Rockford Public Library/Horner.)

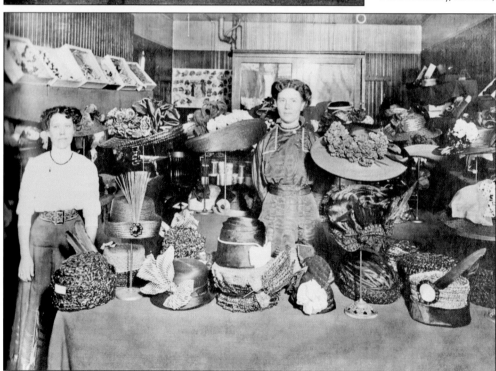

Swanson's Millinery Shop, 1910. Most of the stores in Rockford during this era were family-owned, as was this one at 404 East State Street. After 1904, the width of hats decreased, concentrating instead, until 1907, on the height. These smaller hats have trimmings highlighting the important fashion feature of height. (Courtesy of Midway Village Museum.)

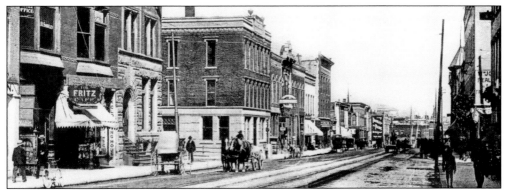

EAST STATE STREET AT SECOND STREET. This photograph looks west down the extensive State Street business district, which thrived from the 1880s through the early 1900s. The streets featured small shops for food, dry goods, and hobby supplies, as well as banks, doctor's offices, barbers, and restaurants. (Courtesy of Midway Village Museum.)

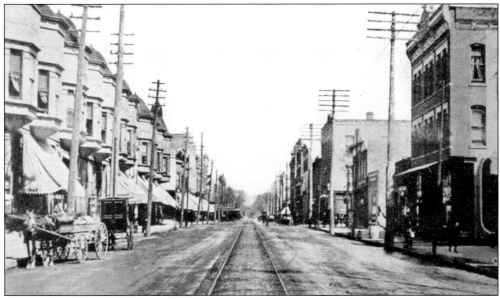

600 BLOCK, SEVENTH STREET. In this view looking north, this shopping district area developed with the help of Gilbert Woodruff, a Rockford banker and real estate developer. Almost anything could be purchased on Seventh Street, and it was required that all clerks speak Swedish, since their clientele was mostly Swedish. Up until the late 1950s, there were stores and offices stretching for about a mile down Seventh Street. (Courtesy of Midway Village Museum.)

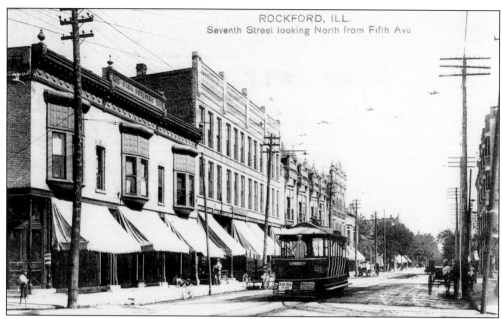

ROCKFORD, ILL.
Seventh Street looking North from Fifth Ave

500 BLOCK, SEVENTH STREET. In 1895, there were three Swedish restaurants and seven Swedish barbershops on Seventh Street. The owners of Peterson's Restaurant later started the well~known Stockholm Inn, which still operates today. At the left end of the block was the Swedish American Bank (later Amcore Bank). The 500 block was the center of the Seventh Street shopping district, with a bank, Eklund's Smorgasbord Restaurant, two Swedish bakeries, grocery stores, a paint store, a furniture store, and others. Below, a 2010 photograph shows the entire west side of the 500 block devoted to the Amcore Bank main center. In 2010, Amcore was sold to the Harris Bank, and in 2011, the building was purchased by the Rockford Board of Education and is now its administrative center. (Both, author's collection.)

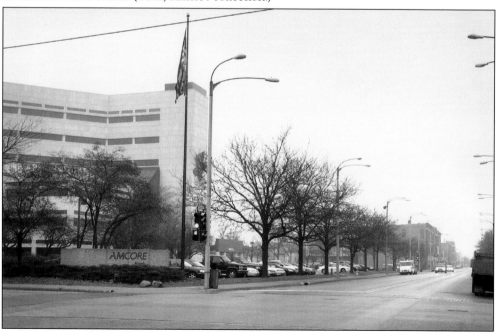

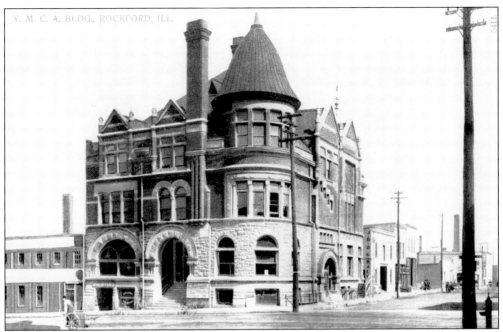

YMCA, 1906. The YMCA building at the corner of State and Madison Streets was erected in 1888 at a cost of $50,000. The structure is located on the northwest corner of East State and North Madison Streets. Later, it was the East Side Inn, and it is still a prominent city landmark. In 1926, P.A. Peterson donated a large sum of money to reconstruct the YMCA on a site on the banks of the Rock River. (Author's collection.)

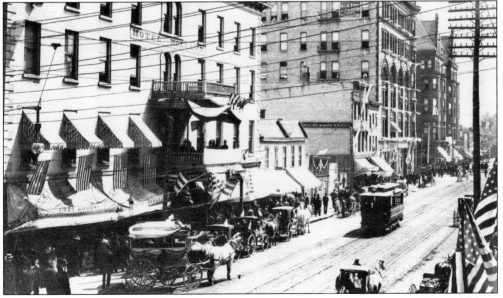

HOLLAND HOUSE HOTEL, 1890. The 150-room Holland House was the center of social life in Rockford from when it was built in 1855 until its tragic demise on Christmas Eve 1899, when candles on a Christmas tree in a neighboring gift shop started a fire. Rockford business meetings, social events, weddings, and conferences were held at the hotel. (Courtesy of Rockford Public Library/F.C. Price.)

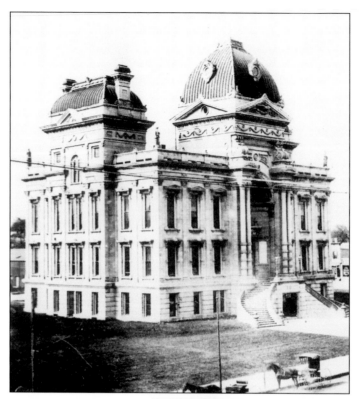

WINNEBAGO COUNTY COURTHOUSE. Winnebago County was formed in 1836 from unorganized land in Jo Davis and LaSalle Counties. This is the second courthouse built on this site. Construction began in 1875 and was completed in 1878. (Courtesy of Rockford Public Library/F.C. Price.)

WINNEBAGO COUNTY COURTHOUSE COLLAPSE. On May 11, 1877, "the greatest disaster in the history of the city" occurred when the courthouse dome collapsed. All but the front pediments fell completely through the center of the building due to faulty design by the architect, Henry L. Gay, who did not plan for the weight or the dome in planning reinforcements. (Courtesy of Rockford Public Library.)

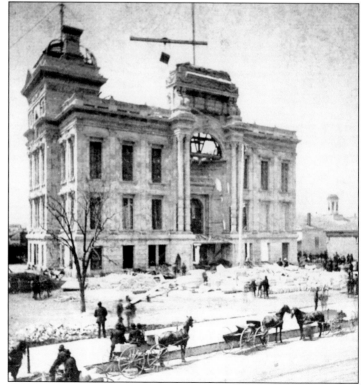

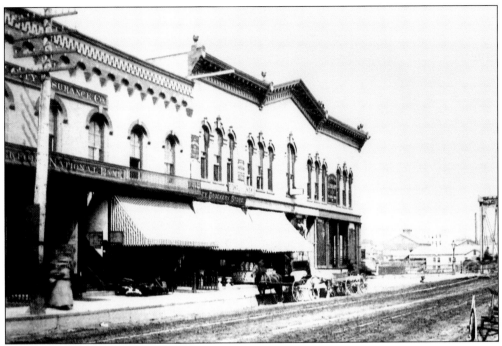

THROUGH-TRUSS BRIDGE LOOKING EAST, AROUND THE 1870S. Wagons and pedestrian traffic traveled across this bridge on East State Street. The office of the temperance organization is on the left, and on the right are the Forest City Insurance Company, the Crockery Store, and the office of the *Register Gazette*. (Courtesy of Midway Village Museum.)

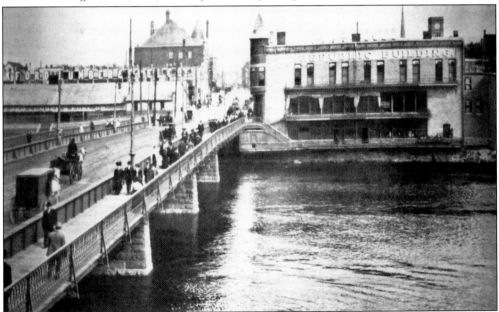

STATE STREET PONY GIRDER BRIDGE. In 1890, the through-truss bridge was moved from State Street south to Chestnut Street to replace a badly worn bridge. In its place, a pony girder bridge was constructed. The truss bridge remained at Chestnut Street until it was replaced in 1917. (Courtesy of Rockford Public Library/Horner.)

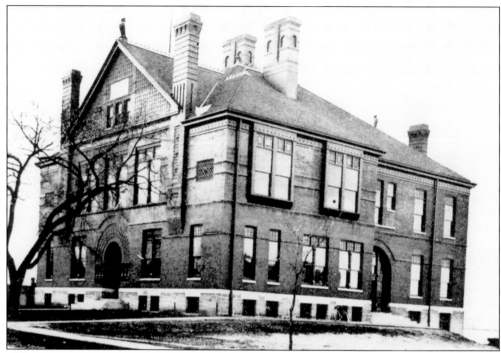

NEW CENTRAL HIGH SCHOOL, 1885. Up until 1885, Rockford had at least three high schools in different parts of the city. After many disagreements about whether to build the high school on the east or west side of the river, Rockford Central High School was finally built at 201 South Madison Street. (Courtesy of Rockford Public Library/F.C. Price.)

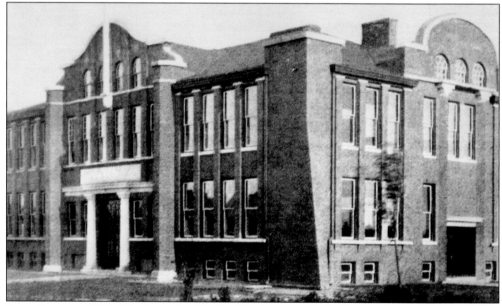

ELLIS SCHOOL, 1868. The first school in Rockford was taught by Eunice Brown in 1837 in a log house with an earth floor, which was used until 1884. The Ellis School was built in 1868 for $4,000. The school is still present, although the original building was razed and new structures were added in the 1970s and 1990s. (Courtesy of Rockford Public Library/F.C. Price.)

Six

BRANCHING OUT FROM FURNITURE

Some industries are dependent on power, some on fuel, others on raw materials, and many others are tied to commercial markets. But some industries are free to locate wherever the inventiveness of leaders and a skilled labor supply are found. The industries in Rockford's central industrial district were the latter, based to a high degree on the city's human element.

From the 1870s until 1920, Rockford fostered and supported industrial genius and had a source of immigrants who were innovative and productive employees, working for wages below those paid to eastern competitors. The town's financial leaders fostered a willingness to supply capital to those inventors with exciting new ideas on how to improve products.

It is impossible to list all the Rockford residents whose inventions stimulated the city's industry, but a few deserve mention. Rockford's most famous inventor of machinery was John Nelson, a furniture man, who experimented with mechanisms in an entirely different field—knitting—and invented a knitting machine, birthing a new industry in Rockford. Charles Hadorff designed a piano, which became world-famous for quality. W.F. and John Barnes invented several types of saws, drills, lathes, and other tools, propelling the machine tools industry.

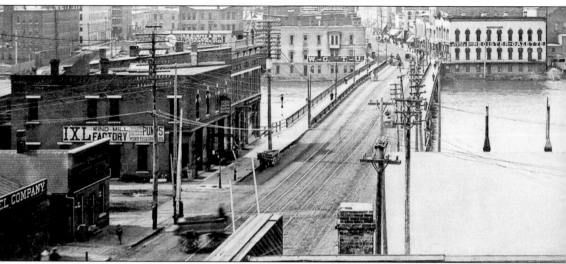

LOOKING WEST OVER STATE STREET GIRDER BRIDGE. The office of the *Rockford Register* is on the left along with Rockford Lumber and Fuel and a windmill shop. Electrical power poles are plentiful in the center of the photograph. Built in 1890, the girder bridge is seen here later in that decade. (Courtesy of *Rockford Today*, 1904, published by Register Star.)

CHARLES HADDORFF. Trained in both Germany and Sweden, Haddorff (1864–1928) was considered an expert on European piano styles, piano acoustics, and tone and scale technique. (Courtesy of Rockford Public Library.)

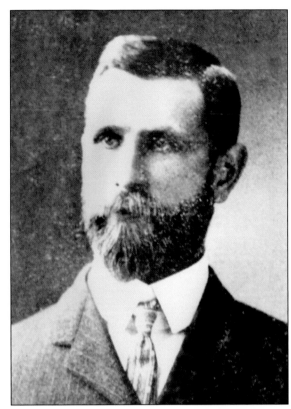

HADDORFF PIANO FACTORY. The Haddorff Piano Company was one of the largest plants in the United States devoted exclusively to pianos. P.A. Peterson wanted to begin building pianos as a supplement to his ventures in furniture. He had heard about Haddorff's talents and invited him to come to Rockford. The Haddorff Piano Company opened in 1903 at 55 Ethel Street, close to the present location of Sinnissippi Gardens. (Courtesy of Midway Village Museum.)

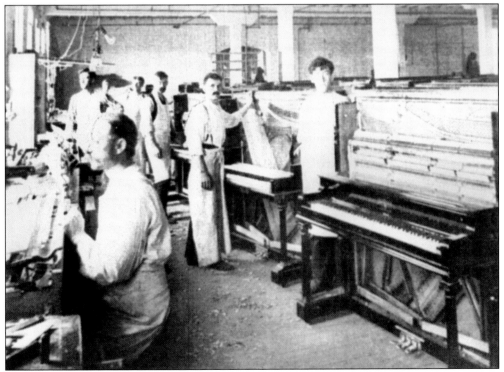

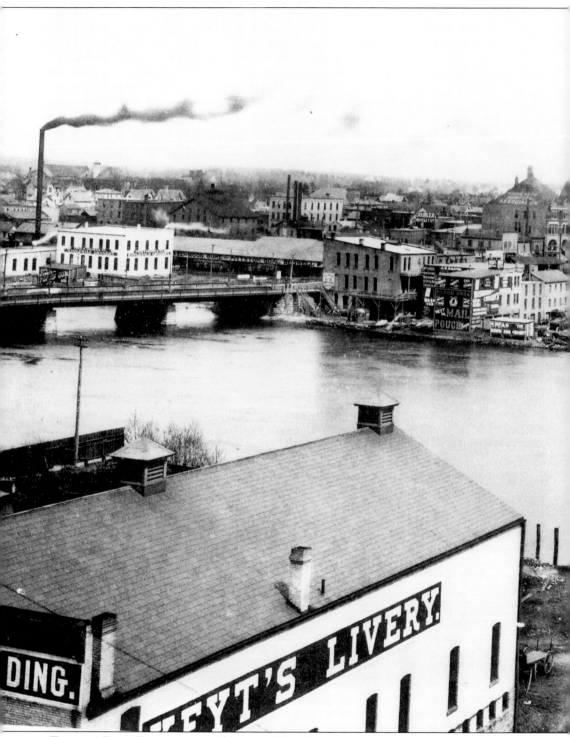

THROUGH-TRUSS BRIDGE, 1893. This view of the through-truss bridge was taken from the Brown Building on South Main Street, after the bridge had been moved down the river from State Street in 1890. The steeple at center right is St. James Church, and the steeple to the far right is First

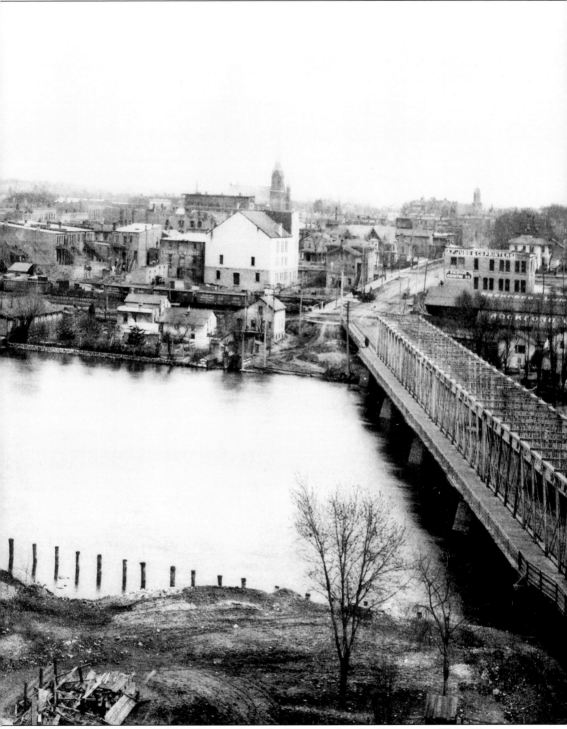

Lutheran. The large peaked building in the right foreground is the Germanica Club. (Courtesy of Midway Village Museum.)

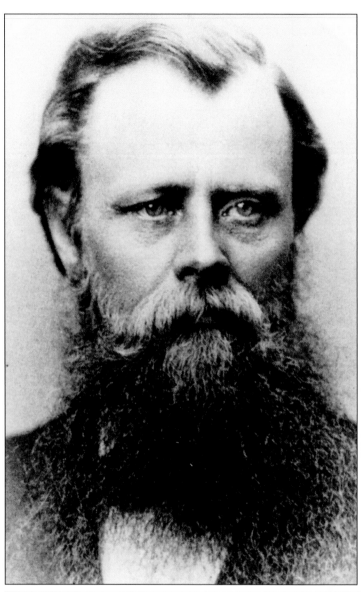

JOHN NELSON. Born in Sweden in 1830, Nelson came to Rockford in 1852 and established the Nelson Knitting Company in 1870. In his later years, Nelson invented and perfected the Nelson knitting machine, which knit socks entirely by machine, revolutionizing the manufacture of socks. (Courtesy of Midway Village Museum.)

NELSON KNITTING MILLS. Along with a group of investors, Nelson's son, William, put his father's invention to practical use, beginning production of "William Nelson's 'Seamless Sock.'" At its high point, the company produced 18 million pairs of socks each year. President Grant visited a Rockford plant in 1879 and declared that he had never seen such perfect machinery as the Nelson knitting machine. (Courtesy of Rockford Public Library/Wheat.)

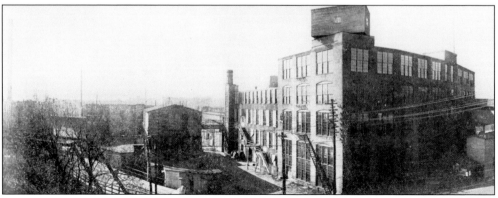

WILLIAM NELSON. William Nelson followed his father as head of the Nelson textile businesses and became the moving force behind sock production, utilizing his father's invention. (Courtesy of *Rockford Today*, 1904, published by Register Star.)

COL. WILLIAM NELSON HOME. William Nelson purchased his home at 737 North Main Street from John P. Manny in 1891. The home was the site of many social functions in the 1890s and early 1900s. Nelson was given the title of colonel by Illinois governor Richard Yates Jr., was president of the Forest City Knitting Company and the Nelson Knitting Company, and had financial interest in several other factories. (Courtesy of Rockford Public Library.)

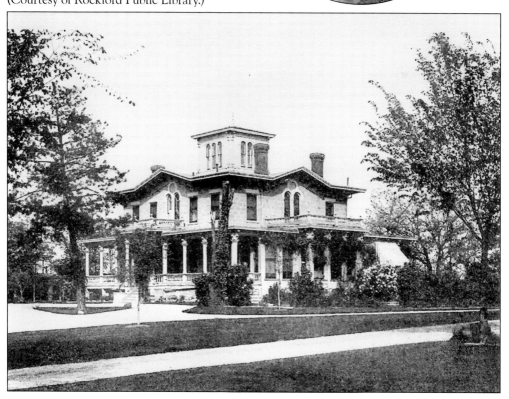

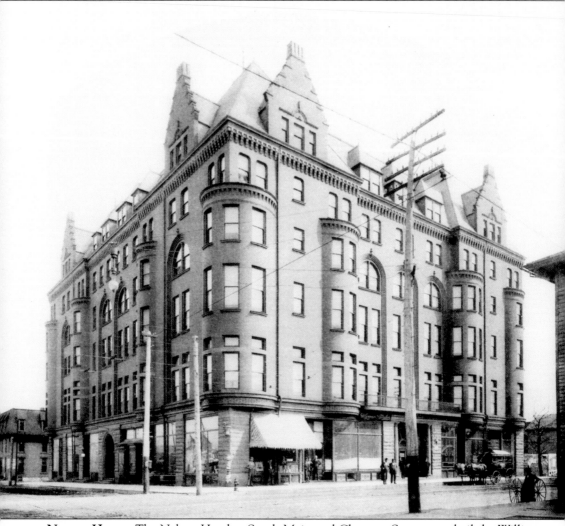

NELSON HOTEL. The Nelson Hotel at South Main and Chestnut Streets was built by William Nelson and his brothers in memory of their father, inventor John Nelson. The hotel was completed in 1893 at a cost of $250,000. There were over 300 rooms in the hotel, and the ground floor featured a flower shop, a magazine and gift shop, and a barber/beauty shop. It was also known for its Jade Room and Crystal Dining Room restaurants. The hotel was demolished in 1965. (Courtesy of Rockford Public Library/F.C. Price.)

Screw-Cutting Lathe. There are no known photographs of John Barnes, but this advertisement is for the screw-cutting lathe, one of the tools that made the W.F. & John Barnes Company famous. It also were known for its foot-powered woodworking tools. (Courtesy of *W.F. & John Barnes Catalog, 1912*.)

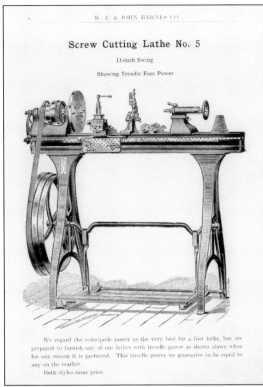

John S. Barnes Home. John S. Barnes built this Victorian home on Guilford Road outside of Rockford in the early 1900s. His father's invention of the powered scroll saw led to an entire line of industrial saws, lathes, and other power tools. (Courtesy of Rockford Public Library/Horner.)

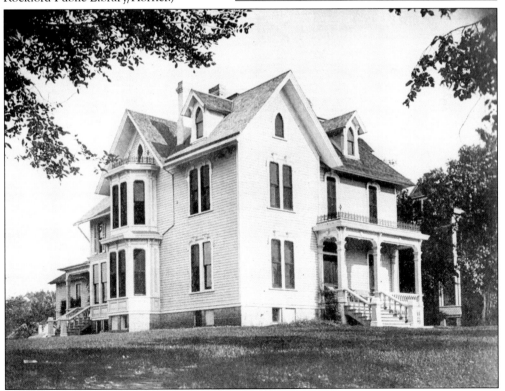

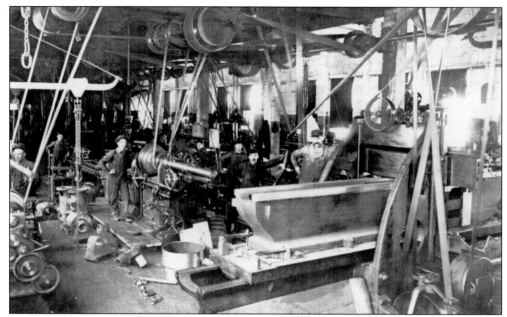

FACTORY ASSEMBLY AREA. While working as a wood model maker for Emerson Talcott and Company, John Barnes made a wooden model of a foot-powered woodworking tool, called a scroll saw. In 1872, he formed a partnership with his brother, and they started the W.F. & John Barnes Company, incorporated in 1884. The belt drive system shown here provided power for the entire assembly area. (Courtesy of Rockford Public Library/C. Daly.)

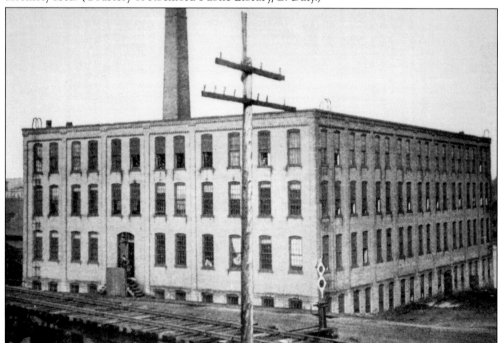

W.F. & JOHN BARNES COMPANY PLANT. Energy for this Madison Street plant, the first power tool plant started by John Barnes and his brother, was provided by a water turbine and later by electricity. (Courtesy of Rockford Public Library/Wheat.)

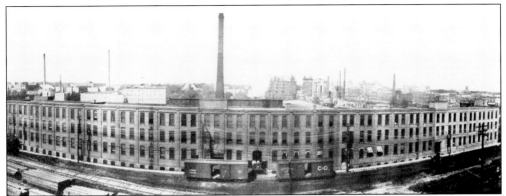

W.F. & John Barnes Company. As John Barnes invented and took orders for more and more exceptional tools, his plant on the Rock River expanded, and in 1904, his Water Street plant stretched for two blocks along the riverfront. The machines turned out here were known as Barnes Drills and Barnes Lathes. (Courtesy of *Rockford Today*, 1904, published by Register Star.)

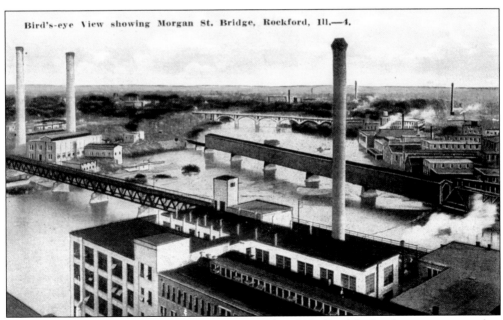

Looking South From the Ziock Building. In the 1880s, Rockford industries continued to expand and diversify into industrial areas on both sides of the river. Companies began looking for land outside the central city, especially since waterpower was no longer used. This image shows both riverbanks and the Rockford generating plant on the far left in the background. (Courtesy of Midway Village Museum.)

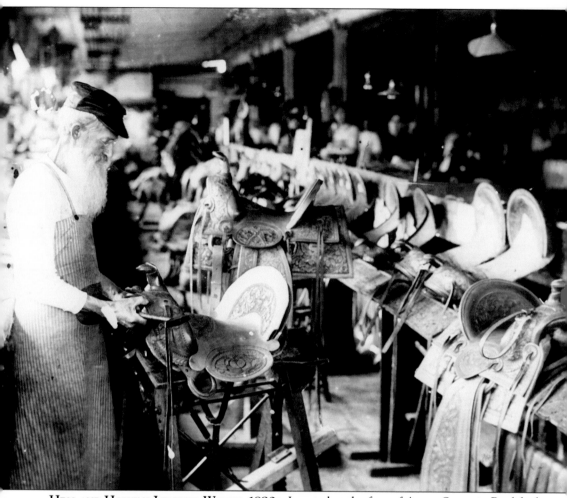

HESS AND HOPKINS LEATHER WORKS, 1890S. Located at the foot of Acorn Street in Rockford, Hess and Hopkins began making horse collars, harnesses, and other leather devices for the city and the farm in 1882. At its peak, the company employed over 450 workers and tanned over 360 cowhides each workday. Mechanized farming and automobiles gradually eroded the need for leather products associated with horsepower, but the company continued producing saddles like these until it was liquidated in 1960, after the death of then owner Arthur Hopkins. (Courtesy of Midway Village Museum.)

Seven

ROCKFORD BECOMES THE FOREST CITY

From the birth of Rockford, residents have been concerned with taking care of the beautiful environment surrounding the Rock River Valley. Early author Henry Thurston first viewed Rockford in 1837 and wrote that the land surrounding the Midway River ford "became clothed in green and it presented the most beautiful landscape I have ever seen, innumerable flowers dotted the scene in every direction and the woods surrounding were covered with sturdy white oak."

In the 1880s, Dr. Elisha Dunn played an important role in the development of conservation principles and the planting of trees in the community. For two years, he served as alderman of the fourth ward, and in the late 1880s, he was appointed by the mayor to serve as superintendent of parks. After the Rockford Club funded studies on the need for an extensive parks and recreation program, Robert Rew, Robert Tinker, and industrialist Levin Faust worked with the Rockford City Council to organize the present system in 1909. Over the next 20 years, the system grew to include 52 parks and playgrounds on 1,123 acres. Many were planned by Paul B. Riis, a national authority on park development who was also superintendent of the park system for many years.

Fay Lewis was president of the park board from 1937 to 1942 and worked with the board to increase efforts to acquire additional land for park purposes. The Wait Talcott family's donation of land for Blackhawk Park served as an impetus for a series of sizable donations, which increased the park district's holdings substantially and encouraged others to continue the pattern of land donation still seen today. Another large land gift was donated by Winthrop Ingersoll, who gave the 151-acre tract of land in the southwest of the city known as Daisy Field. Ingersoll gave it in memory of his son, Clayton, who died in World War I, and much of the land is now part of the Ingersoll Golf Course. Recent gifts of land resulted in facilities like the Elliott and Aldeen Golf Courses.

ROBERT TINKER AND LEVIN FAUST. Robert Tinker (left) and Levin Faust (right) were some of the first park commissioners for Rockford. Tinker was a self-taught park designer and a volunteer worker. Faust, a dedicated philanthropist, investor and manufacturer, became a long-serving president of the park board from 1913 to the early 1920s. Faust and Tinker were the foremost advocates for a Rockford park system to enhance the city environment. (Both, courtesy of Rockford Park District.)

HASKELL PARK, 1920. In the period before a park district, public-spirited citizens donated block or triangle sections for small parks that were contiguous to the various neighborhoods. Dr. George Haskell and his brother-in-law, John Edwards, presented this park to the city. It had been called the West Side public square but was renamed Haskell Park. (Author's collection.)

FRED CARPENTER. Fred E. Carpenter, a Rockford lawyer, was one of several citizens who spoke to community groups in support of forming the Park District. He was a parks commissioner and the first park district president. (Courtesy of Rockford Park District.)

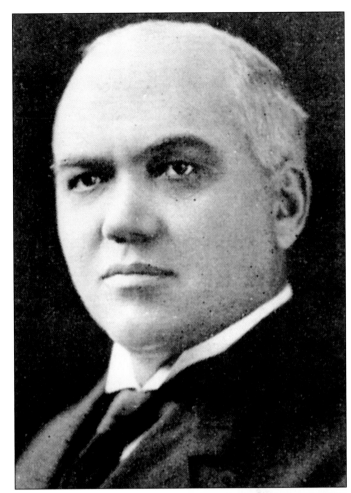

SINNISSIPPI PARK. In 1909, the first transaction of the park board was the purchase of the 77-acre "Rood Woods" tract of land for $47,500. The board also voted to pass a bond issue of $100,000, and the money was used to buy additional land in the same area. The purchase of this additional acreage created the 123-acre Sinnissippi Park, the largest in the city. The park was named to preserve the Indian name for the Rock River, *Sinnissippi,* or "Clear Flowing." (Courtesy of Rockford Park District.)

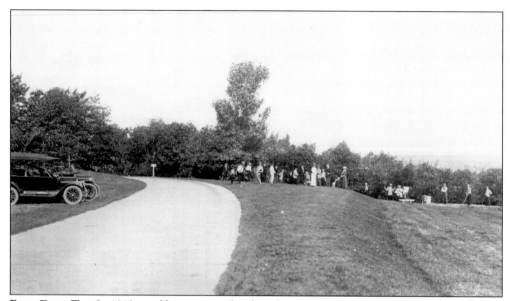

BUSY FIRST TEE. In 1912, a golf course was developed in the new Sinnissippi Park. The nine-hole course opened in 1913 and was a sensational hit. This image, from a year later, shows golfers lined up waiting to get started on the first tee. Even at this early time, female golfers joined the men. (Courtesy of Rockford Park District.)

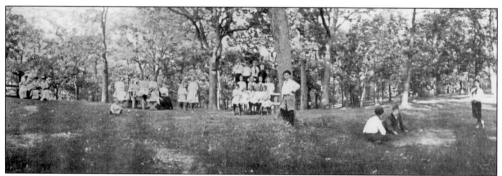

CHILDREN'S PLAYGROUND, 1911. The Sinnissippi Children's Playground was opened in 1912, the nearby tennis courts in 1914, and the baseball field in 1915. Within four years of opening, the park district hired playground supervisors to develop programming for all ages. (Courtesy of Rockford Park District.)

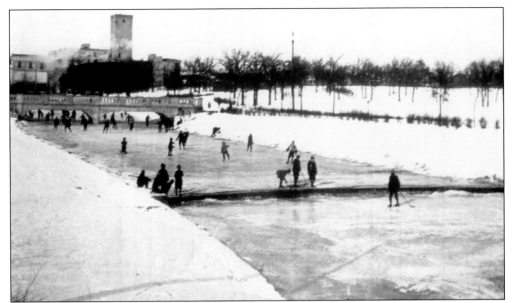

ICE SKATING AT FAIRGROUNDS PARK. In February 1904, Rockford City Council purchased the county fairgrounds for $5,280, and it voted that summer to build a concrete dam across Kent Creek to create a swimming pool in the summer and an ice skating rink in the winter. The city turned over the park to the park district in 1909. (Courtesy of Rockford Park District.)

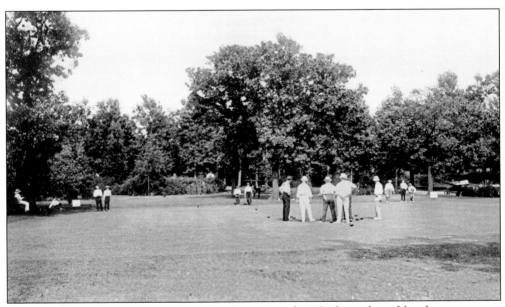

BOWLING GREEN FAIRGROUNDS PARK. In the spring of 1925, this enlarged bowling green was planted in bent grass. The excellent facility prompted the Rockford Lawn Bowling Association to invite the Midwest Lawn Bowling League to Rockford for its annual tournament. The Washington Club from Chicago won the tournament, and Rockford placed second. (Courtesy of Rockford Park District.)

65

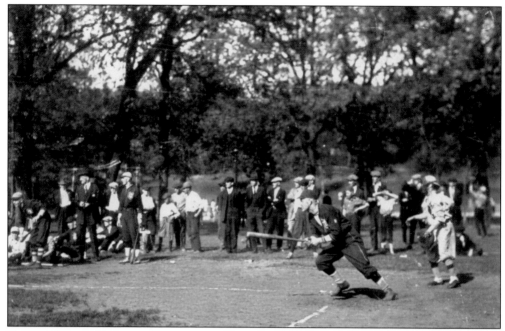

FACTORY LEAGUE BASEBALL, FAIRGROUNDS PARK. By 1916, the park district had 16 teams involved in factory and commercial baseball, and by 1925, there were more than 40 teams competing. Each year, a company such as Barber-Colman or Ingersoll would sponsor a city championship, and the winning teams were given a trophy for their efforts. Rockford was referred to as "the cradle of the national game in the West." (Courtesy of Rockford Park District.)

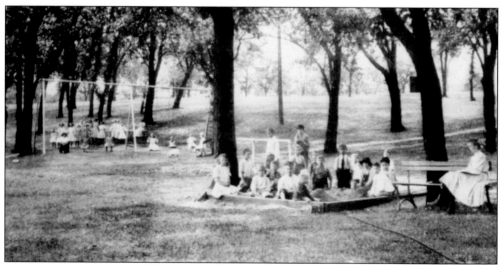

FAIRGROUNDS PARK SANDBOX. The 24-acre Fairgrounds Park had a fully equipped playground with slides, swings, separate play areas for boys and girls, and a huge coeducational sandbox. In addition, the park had a creek, a swimming pool/skating pond, three ball diamonds, seven tennis courts, bowling greens, quoits target areas, a one-third-mile running track, and a football field. (Courtesy of Rockford Park District.)

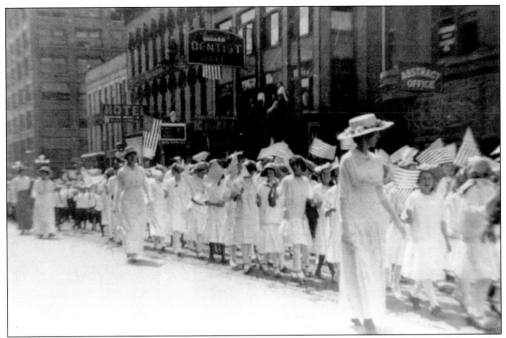

MARCHING AT SPRING FESTIVAL. In 1913, the schools decided to conduct a parade to celebrate the end of the school year and the new park system. The entire student bodies of all eight elementary schools participated. About 8,000 children and their teachers marched to the park and conducted a spring pageant including exercise routines, race contests, and a culminating activity. (Courtesy of Rockford Park District.)

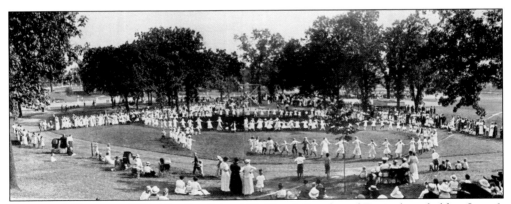

CHILDREN'S FESTIVAL, 1913. The first School Children's Parade and Festival was held on June 6, 1913. The children coordinated formations in a rose drill, sang songs, and conducted readings. The activities and programs were designed to celebrate the cultures of the immigrants who attended the schools along with their American classmates. Parents with children in the elementary schools were invited to attend. (Courtesy of Rockford Park District.)

SURVEYING, BLACKHAWK PARK. Robert Tinker made the 1911 design for Blackhawk Park. Care was taken to preserve the natural environment to as great a degree as possible, and the Nature Study Society actively supported it, surveying plant and animal populations. Paul Riis, the president of the Nature Society, became the superintendent of the park district. (Courtesy of Rockford Park District.)

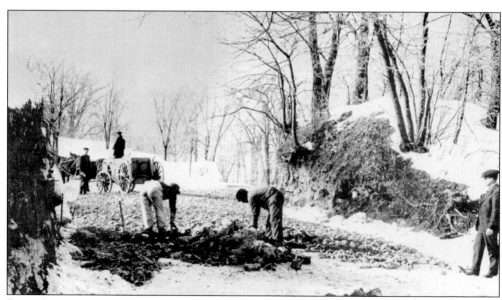

ROAD CONSTRUCTION, BLACKHAWK PARK. In its formative years, the park district spent most of its revenues improving the 13 city parks and constructing the access roads. Here, workers use gravel from the Blackhawk Quarry to construct a roadway to the new shelter house. Only manpower and horsepower were used to make a cut through this hill. (Courtesy of Rockford Park District.)

THE MONKEY HOUSE, BLACKHAWK PARK ZOO. From 1919 to 1921, Rockford had its own zoo, in Blackhawk Park. The Rockford Zoological Society was formed to develop and maintain a zoo in the park. It built cages and shelters for the animals and was able to secure animals that were a great attraction for citizens, including a Bengal tiger, monkeys, a buffalo, and several other small animals, some of them native to the area. (Courtesy of Rockford Park District.)

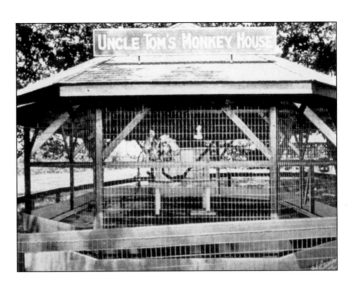

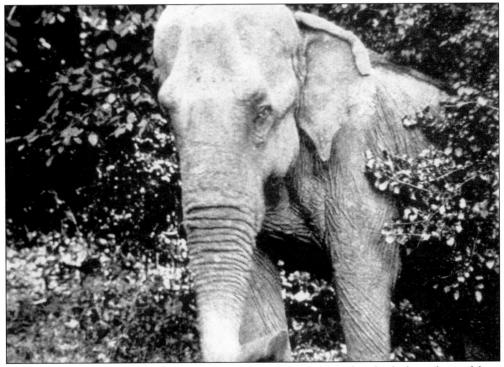

BIG BABE THE ELEPHANT. The zoo's main attraction was Big Babe, a female elephant donated from the Ringling Brothers Circus. Although the elephant was a welcome donation, the society quickly learned how much food elephants ate. The food for the animals depleted the society's funds and in desperation, they asked the park district to assume responsibility for maintaining the zoo. It closed in the fall of 1921 due to a lack of financial support. Pictured here is an elephant—perhaps Babe herself. (Courtesy of Rockford Park District.)

MANDEVILLE HOUSE MUSEUM, 1917. The 3.5-acre Mandeville Park and Mandeville House were donated by Harriett Mandeville Gilbert. By 1918, the Nature Study Society had a collection of birds, bird and reptile eggs, birds' nests, mounted animals, minerals, fossils, shells, and Indian relics, all of which were identified and classified. The group opened the museum to the public each Sunday afternoon. (Courtesy of Rockford Park District.)

MANDEVILLE PARK, 1916. These two young children wait for a park playground supervisor at Mandeville Park, where there were no organized game or craft activities. In 1915, the park district developed programs with games, folk dances, and music for six of the larger parks, all of which had supervised play and even gender-specific playgrounds. (Courtesy of Rockford Park District.)

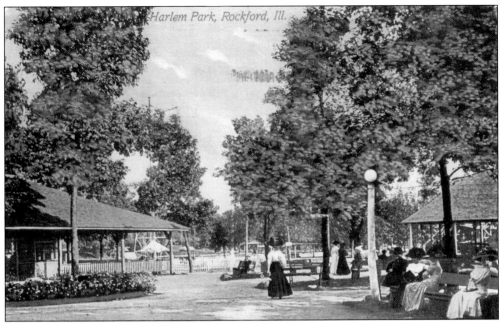

CENTER PROMENADE, HARLEM PARK. In 1890, a group of men who were invested in the city trolley system recorded the plat of an area between the Rock River and Auburn and North Main Streets, naming it Harlem Park Subdivision. Later that year, a group of speculators purchased 47 acres of the subdivision for the purpose of developing an amusement park for Rockford, which opened in 1891 to a horde of visitors. (Author's collection.)

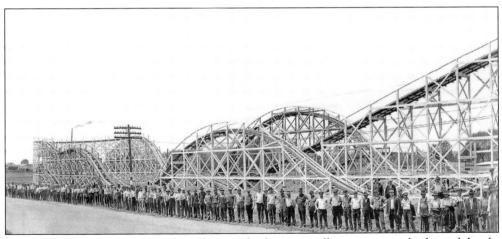

ROLLER COASTER, HARLEM PARK. This figure-eight three-way roller coaster was a big hit with locals. Harlem Park closed in 1928, and in 1929, Charles O. Breinig moved the Harlem Park roller coaster from its former site to Central Park, where a large crew of men reassembled the wooden coaster. It was renamed the Scream Machine and ran into the 1940s. (Courtesy of Guy Fiorenza.)

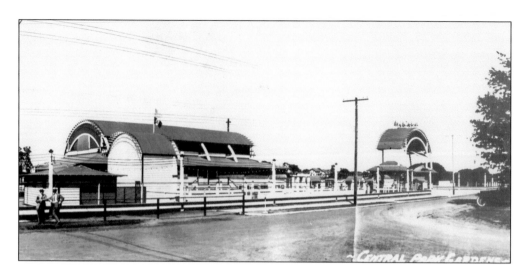

CENTRAL PARK, 1937. In 1928–1929, Charles O. Breinig rebuilt many of the rides from the old Harlem Park and reassembled them at the new Central Park at 3400 Auburn Street, which had opened on May 28, 1921. The above image shows the entrance gate to the park on a summer day in 1923. Below, the stage and beer garden are flooded by Kent Creek in the spring of 1942. The park was finally closed in the fall of 1942 due to frequent spring floods. (Both, courtesy of Guy Fiorenza.)

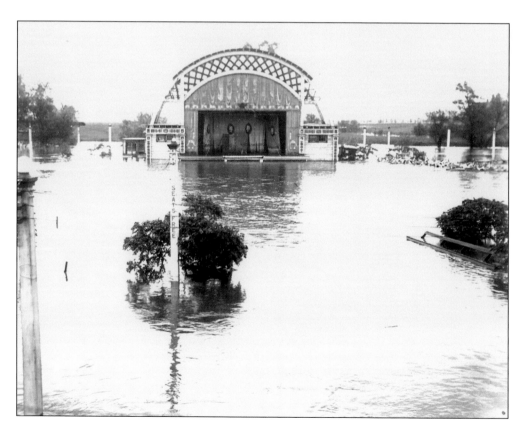

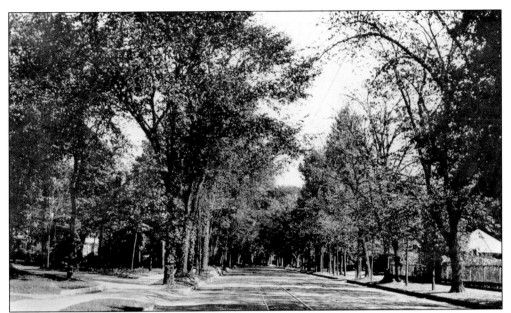

NORTH CHURCH STREET FROM HASKELL PARK, 1890. North Church Street was the place to be for up-and-coming business, professional people, and factory supervisors. From the 1890s to 1920, the houses were mostly two-story Victorians. The street is covered with an archway of trees, planted by residents and the city street department. (Courtesy of Rockford Public Library/Wheat.)

DOWNTOWN ROCKFORD. This 1920 image shows the American Insurance office (far right) and the Shrine Temple (near left) on the 300 block of North Main Street. In 1926, almost all the residences were demolished to make room for the Coronado Theater at 314 North Main Street, which is now listed in the National Register of Historic Places. (Courtesy of Rockford Streamlined/ Fred F. Rowe.)

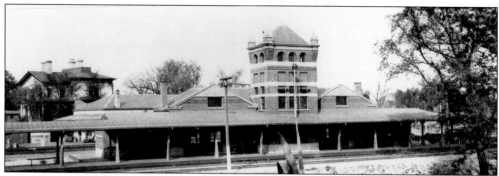

Illinois Central Railroad Depot, 1890. This train depot for the Illinois Central Railroad was built in 1888, when almost 60 trains a day stopped here. Passengers arriving and departing had a beautiful view of the gardens designed by Robert Tinker. John Manny's mansion is in the background. (Author's collection.)

Tinker Park and Cottage. Robert Tinker created this garden directly south of the Illinois Central tracks and depot. The park and Tinker Cottage in the background were donated to the park district when Tinker's second wife died in 1942. (Courtesy of Midway Village Museum.)

Eight

MECHANICAL GENIUSES

In the early 1900s, the influx of inventions in the machine tool industry and the awarding of defense contracts to Rockford companies provided good-paying jobs for thousands of employees. And once the new items hit the market, there was substantial and continuous demand for Rockford products.

Elmer Woodward invented a governor for waterwheels, and the Woodward Governor plant later became the world's largest factory devoted exclusively to the production of governors. Just like John Nelson before him, Howard D. Colman, a young inventor from Beaver Dam, Wisconsin, began toying with ideas for textile machinery as a hobby. He developed the hand-knotter, for splicing two threads together with a knot. His major invention, his warp-tying machine, fostered the development of the Barber-Coleman Company.

Levin Faust arrived in Rockford in June 1887 with 50¢ in his pocket. He took up the mechanics trade, working in the machine shop for W.F. & John Barnes Company. While at Barnes, Faust and three other mechanics began to work in their spare time on an engine and boiler salvaged from an industrial fire. Using the refurbished boiler and other salvaged equipment, the formation of Mechanics Machine Company was underway by 1890. In 1912, the company succeeded with a patent for a truck transmission, which became the firm's flagship product.

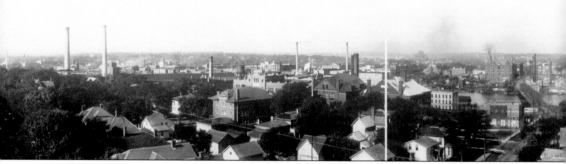

ROCKFORD PANORAMA, 1911. This view looking east from the courthouse shows Rockford's development as an industrial city by 1900, by which time Rockford had a population of about

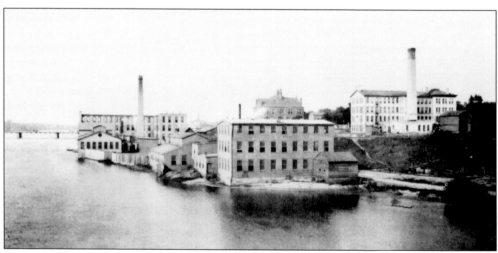

EAST BANK OF ROCK RIVER, 1912. The east side of the river, seen from the Chicago and North Western Railway tracks, has industries from the bank of the river up to South Madison Street. The tall smokestack of the W.F. & John Barnes Company is in the left background, the Ward Pump Company is in the center foreground, and on top of the hill is the Rockford Watch Company. The peak-roofed building in the center background is Rockford Central High School. (Courtesy of Rockford Public Library/F.C. Price.)

47,000 and over 450 manufacturing plants. (Courtesy of the Library of Congress.)

LEVIN FAUST. Faust was an inventor of mechanical parts for machines who also wrote a book about the history of Rockford in Swedish. He was very successful as an industrialist in the first quarter of the 20th century and was a long-serving park board president and community leader. (Courtesy of *Rockford Today*, 1904, published by Register Star.)

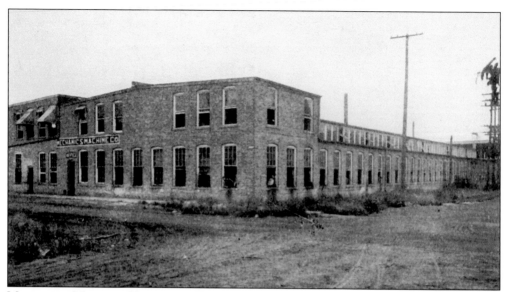

MECHANICS MACHINE COMPANY, 1912. The formation of Mechanics Machine Company got underway in 1890. Faust was chosen as the secretary-treasurer of the new venture, and he would remain an officer with Mechanics until his death. In 1912, Faust patented a truck transmission that became the mainstay of the firm. The company was later known as Mechanics Universal Joint and moved to this building in the Water Power District in 1897. (Courtesy of Rockford Public Library.)

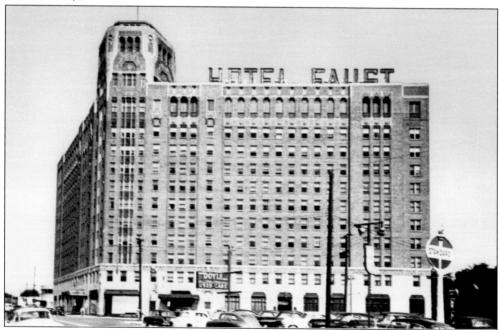

HOTEL FAUST, LATE 1940S. The 15-story Hotel Faust, still Rockford's tallest building, was the final business venture for Levin Faust. In 1928, along with Eric S. Ekstrom and John Wester, he built the $2.7 million hotel, investing the majority of the money himself. The hotel soon felt the results of the Depression and faced financial disaster, and Faust suffered financial ruin as a result of the hotel default. (Author's collection.)

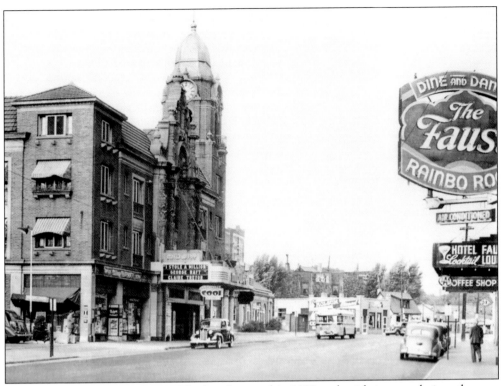

RAINBOW ROOM, HOTEL FAUST. The hotel opened in 1930 and, with its completion, the area became one of Rockford's entertainment centers. The 186-foot-tall hotel was capped by a flagpole over the penthouse. The Faust remained a hotel until 1980, when due to severe losses, the massive building was sold to the Shriners, who renamed it Tebala Towers. (Author's collection.)

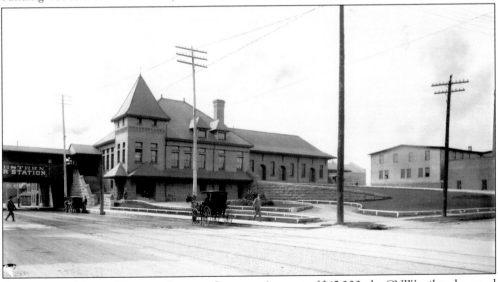

CHICAGO AND NORTH WESTERN RAILWAY STATION. At a cost of $45,000, the CNW railroad opened this impressive overhead station to serve the increasing number of passengers to Chicago and points east and Freeport and Galena to the west. At one point, three eastbound and three westbound passenger trains arrived to and departed from the station. (Courtesy of Library of Congress.)

HOWARD COLMAN. At age 14, after visiting a cotton mill and learning about a knot-tying problem, the inventive wheels started churning in Howard D. Colman's mind. He soon created models of machines designed to simplify manufacturing and received his first patent at 21, for a milking-machine accessory. Later, he patented his famous knot-tying device, the revenue from which funded his new company, the Barber-Colman Company. (Courtesy of Midway Village Museum.)

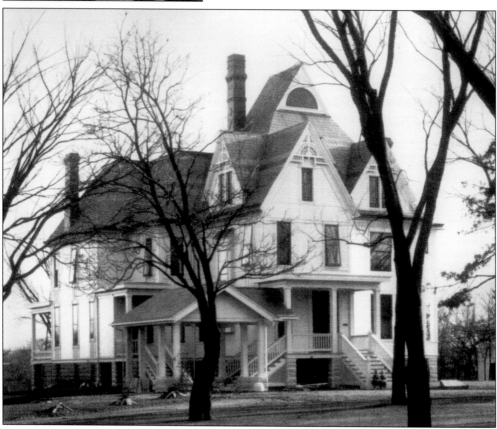

HOWARD COLMAN HOME, 1912. Howard Colman purchased this three-floor Victorian home at 929 North Main Street in 1907 for $41,000, one of the most expensive prices for a house in the city at the time. (Courtesy of Rockford Public Library.)

SPENGLER BROTHERS MACHINE SHOP.
In 1891, when Howard Colman invented his warp-tying device, he decided to have the Spengler Brothers Company build it. With further financial support from William Barber, he kept refining the idea, trying out several models in a Janesville, Wisconsin, cotton mill. (Courtesy of Rockford Public Library/F.C. Price.)

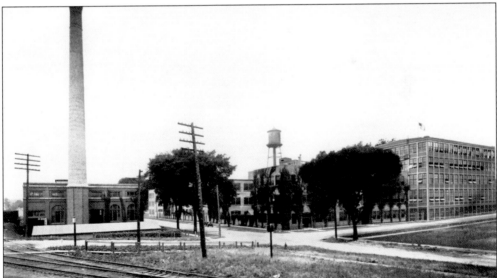

BARBER-COLMAN FACTORY, 1920S. The original Barber-Colman factory, at the corner of River and Loomis Streets, is in the middle of this image. Its first two floors were devoted to the manufacturing of machines, and the top floor was designated for experimentation and development. Howard Colman's inventions did not stop with knitting machines; he also designed remote control motors, ratchet-type motors for vending machines, components for automobiles, and industrial instruments used in recorders and controllers. His many inventions made it necessary to expand the factory to keep pace with production. (Courtesy of Midway Village Museum.)

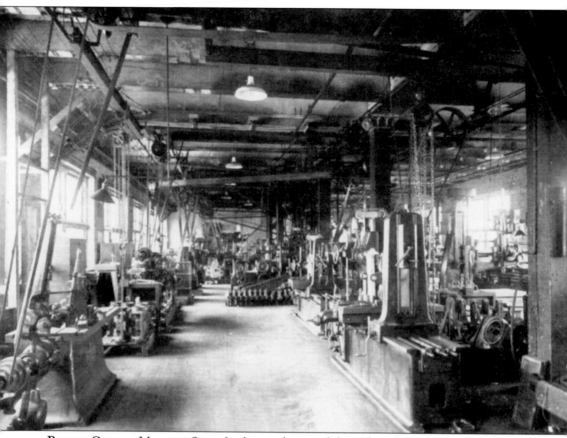

BARBER-COLMAN MACHINE SHOP. In this machine tool shop, the new designs from Colman and his engineers were made into prototypes, including radio-frequency door operators and automotive brakes and clutches. During World War II, Colman researched ideas for jet engines, tank controls, and airborne radar. (Courtesy of *Knot Annual Employees Book*, 1915.)

AMOS WOODWARD. An obsessive tinkerer and inventor, Woodward worked for N.C. Thompson Company in the 1860s and became intrigued with how to control the speed at which waterwheels turned. In 1869, he designed a new mechanism, the mechanical non-compensating waterwheel governor. To produce the device, he started his own company. Even though his idea was practical, he lacked capital, and his business almost failed before his son, Elmer Woodward, took over and saved the company. (Courtesy of Woodward Inc.)

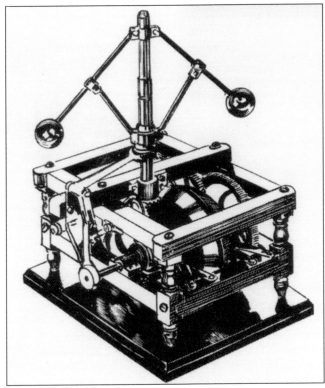

WOODWARD'S FIRST WATERWHEEL GOVERNOR. This model of Amos Woodward's first invention was patented in 1870 and eventually birthed a company with facilities worldwide. A model of a later Woodward Governor aircraft governor was displayed in the Smithsonian Institution in the 1960s. (Courtesy of Woodward Inc.)

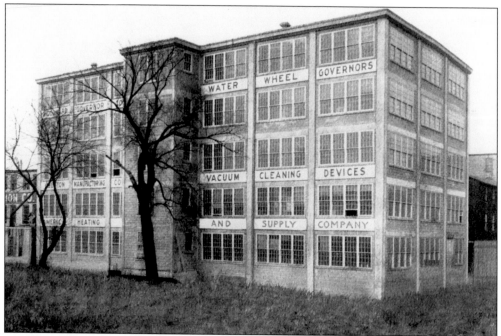

WOODWARD GOVERNOR 1910 PLANT. In 1910, Woodward Governor opened a new five-story plant at 240 Mill Street. Elmer Woodward improved the company's governors to meet new needs in the marketplace and helped the firm become profitable. After Amos Woodward died in 1919, Elmer continued to lead the company through the 1920s. In 1929, when he was 67 years old, Elmer Woodward hired his son-in-law, Irl Martin, to take over day-to-day operations, but Elmer continued to design new products for years. (Courtesy of Midway Village Museum/ Jon Lundin.)

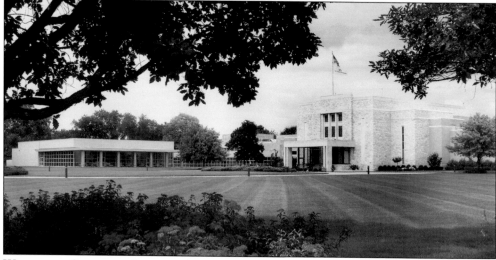

WOODWARD GOVERNOR PLANT. Sales growth in the 1940s changed the face of the company, and it moved into this new factory at 5001 North Second Street at the very start of World War II. Through the years, it has evolved from its start with governors to become the world's oldest and largest independent provider of controls for aircraft, industrial engines, and turbines. The company is now headquartered in Fort Collins, Colorado, and adopted the name Woodward Inc. in 2011. (Courtesy of Woodward Inc.)

Nine

A MACHINE TOOL GIANT

In the 1930s and 1940s, Rockford became a machine tool giant. Through discovering the background behind some of Rockford's largest industries of the 20th century, how Rockford developed to be a national center for machine tools will be shown in this chapter.

In 1911, as a young machinist and a student of mathematics, G. David Sundstrand recognized the potential underlying the idea he had formed about a computing machine so simple and durable that adding machines might be made common articles of commerce instead of the complicated and cumbersome devices they were at the time. He went on to construct a prototype that eventually became a company best seller. With continuing new inventions, his company went on to grow into one of Rockford's largest employers, with a workforce of several thousand. Sundstrand's developed products for producing electric power and aircraft systems for commercial, military, and space applications and played a key role in developing control systems for NASA's space shuttle.

In 1903, three Swedish immigrants saw a need for mortise furniture locks. Together, they invested $5,000 each and established National Lock Company in Rockford. P.A. Peterson and two Aldeen brothers fired from National Lock started their own company and developed innovative machines to produce cabinet hardware. Later, they purchased the lock division of National Lock.

The Testor Corporation grew from the dreams of immigrant Nels Testor, who adapted a formulation by Karlson's Klister into a company producing several different varieties of household cement and wooden and plastic models of famous airplanes and space vehicles.

An inventive Seth Atwood, who grew lip in Rockford, came up with the modern-day invention of an automobile doorstop that led to a variety of accessory products for the automobile industry. With the help of his brother, he opened his own company, which became very successful supplying parts for the automotive industry. Atwood Products flourished for more than 75 years before being acquired by Elkhart, Indiana–based Excel Industries Inc. in 1996.

DAVID SUNDSTRAND AND ED CEDARLEAF. David Sundstrand (left) spent his time designing and developing lathes and centering machines for Rockford Milling Company and Rockford Tool. Oscar Sundstrand began designing and developing the Sundstrand adding machine. Their brother-in-law, Ed Cedarleaf (right), found the finances to manufacture the ideas of the brothers. (Both, courtesy of Rockford Public Library.)

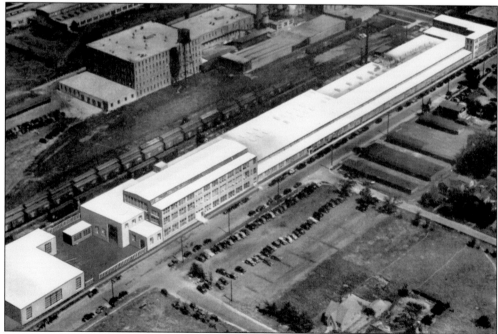

SUNDSTRAND PLANT, ELEVENTH STREET. In 1911, the Rockford Tool Company built a 25,000-square-foot factory one block north of the Rockford Milling Machine plant on Eleventh Street. At this early date, this location was still far from the city, and the companies were so closely knit it was difficult to distinguish one from the other. Later, the two companies adopted the Sundstrand name. (Courtesy of Rockford Streamlined/F. Ford Rowe.)

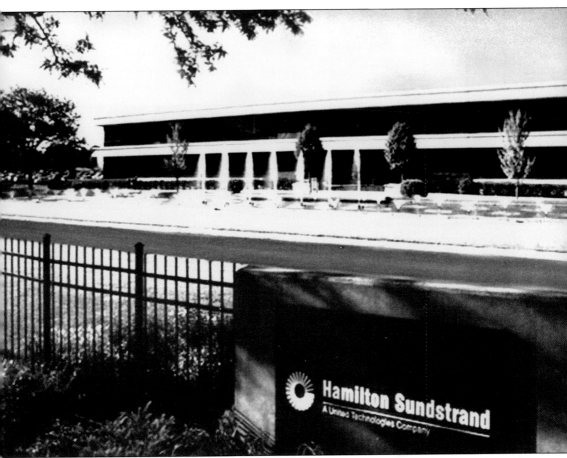

SUNDSTRAND PLANT ON HARRISON AVENUE. In 1999, Hamilton Standard and the Sundstrand Corporation merged, forming the Hamilton Sundstrand Corp. The company now has 50 major facilities worldwide. Hamilton Sundstrand is among the world's largest suppliers of technologically advanced aerospace and industrial products. It has designed space shuttle components and parts for Boeing's new 787 aircraft. Its diverse products range from hydrocarbon, chemical, and food processing materials to construction and mining equipment. (Courtesy of Hamilton Sundstrand.)

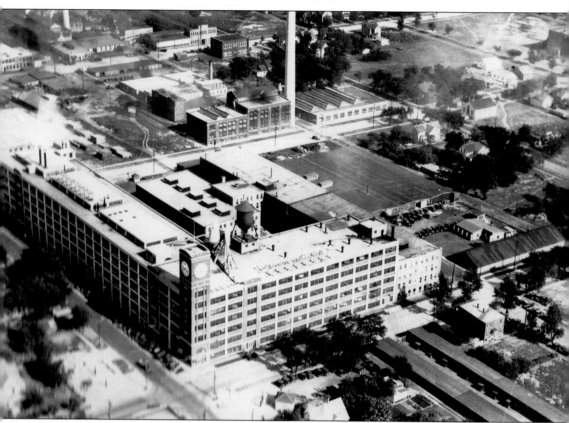

NATIONAL LOCK COMPANY. Levin Faust, P.A. Peterson, and Frank Hogland started National Lock Company in 1904. Faust had just developed a special mortise lock that permitted cabinetmakers to install locks inside the surface of the wood. Faust also patented a door equalizer used by Skandia Furniture and a razor blade sharpener used by many Rockford firms. These inventions became the first National Lock products. In 1919, National Lock built this one-million-square-foot, six-story plant at 922 Seventh Street to expand its production capacity and became Rockford's biggest employer for a time. Further additions were made in 1924 and 1926. After a civil lawsuit involving the company president, National Lock was sold to Keystone Industries. In 1980, the company doors were abruptly closed, and National Lock was moved to South Carolina. (Courtesy of Rockford Public Library.)

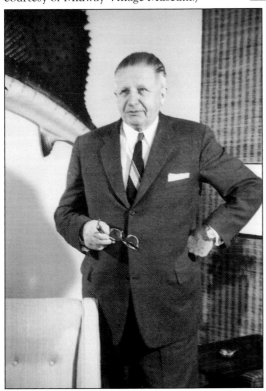

REUBEN AND GEDOR ALDEEN. Gedor Aldeen (below) came to Rockford having been trained as a machine tool maker, and he and his brother Reuben (right) were employed at National Lock Company. Both were fired because of conflict with their authoritarian boss, and they took some of their own inventions with them, patented them, and set up their own company. They were very successful in developing a superior line of cabinet hardware. (Both, courtesy of Midway Village Museum.)

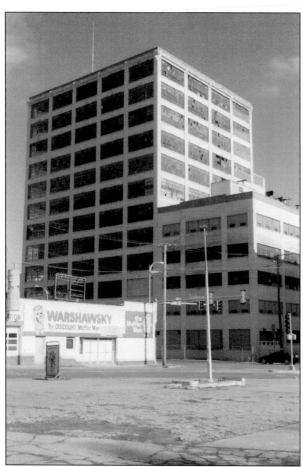

ZIOCK BUILDING AND MAIN AMEROCK PLANT, 1980. In 1928, Reuben and Gedor Aldeen left National Lock Company to establish the Aldeen Manufacturing Company. Their new company first rented space in the city's knitting district, on the twelfth floor of the 13-story William Ziock Building on South Main Street. Eventually, it occupied the entire building. (Courtesy of Bob Anderson.)

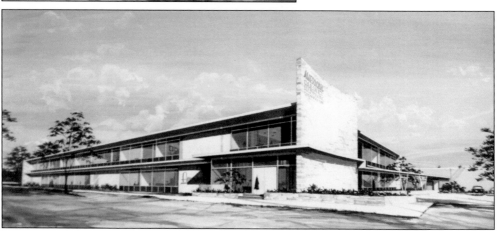

AMEROCK'S 1960s HEADQUARTERS PLANT. In the 1960s, the Aldeen family was still involved in their company, by then called Amerock. Gedor remained chairman, Reuben was president, and Gedor's son, Norris Aldeen, was promoted to executive vice-president in 1961. In July 1987, the Freeport-based Newell Company acquired the company. In the early 2000s, although the company was a success, Amerock was relocated from Rockford to Columbia, Maryland, and then to Huntersville, North Carolina. (Courtesy of Rockford Public Library.)

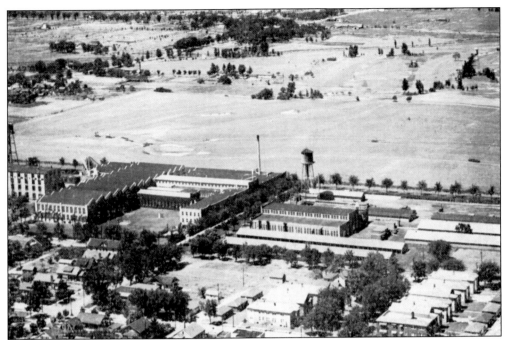

INGERSOLL MILLING MACHINE COMPANY, 1940s. Ingersoll grew with the boom in the automobile industry and the increased production demands caused by two world wars. By 1960, the company employed nearly 1,500 people. In 2002, it was sold to Dalian Machine Tool Group Corporation. (Courtesy of Rockford Public Library.)

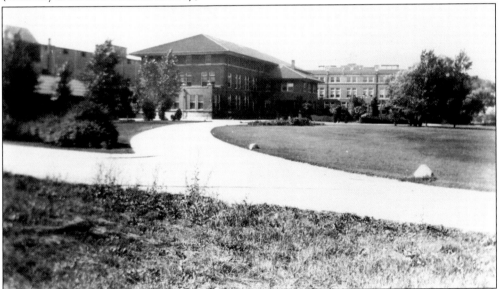

EMERSON-BRANTINGHAM MAIN OFFICE. The Emerson-Brantingham Implement Company was formed in Rockford in 1909, following Charles Brantingham's appointment as president of the Emerson Manufacturing Company. It produced reapers, plows, and other tillage equipment. In 1916, the company developed its own tractor design and two years later, the highly successful Model AA 12-20 was introduced. Production on that model continued until the company was bought by the J.I. Case Company in 1928. (Courtesy of John Inhe.)

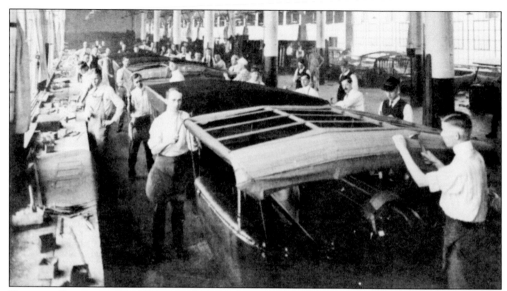

EMERSON-BRANTINGHAM WARTIME WORKERS. By 1915, Emerson-Brantingham was in financial trouble. The market for the heavy tractors it had been making dried up. The company switched to making small tractors and buggies at its plant, and with the advent of World War I, it switched again to building carriages for Army trucks, like the one pictured above in 1917. Emerson-Brantingham became a division of J.I. Case in 1928, and during World War II, it made wings for Army Air Forces bombers (below, in 1944). (Above, courtesy of Midway Village Museum; below, courtesy of John Ihne.)

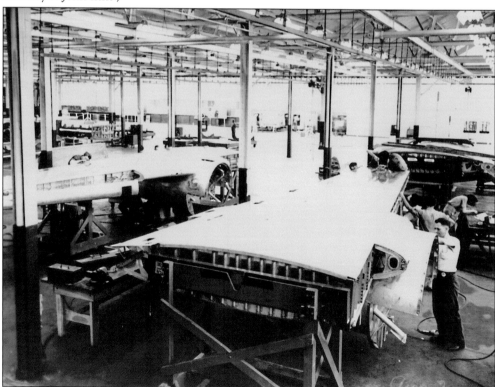

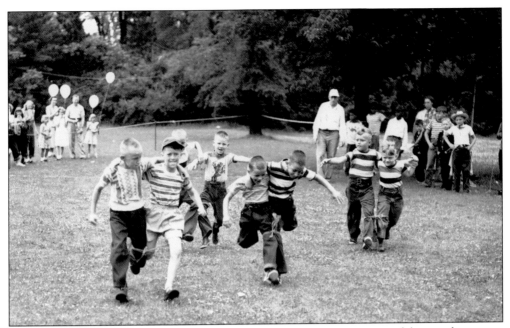

J.I. Case Company Picnic, Mid-1950s. The company picnic was just one of the social activities promoted by one of Rockford's largest employers in the 1950s. The picnic usually included games and prizes for adult workers and rides and contests for children. John Ihne (right) and his brother Merle (left) are the pair at the far right in this three-legged race. (Courtesy of John Ihne.)

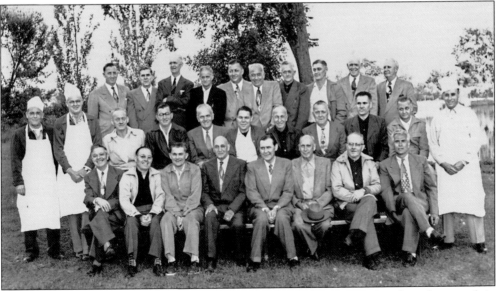

Atwood Vacuum Company. The employees of the Atwood Company pose for a photograph in 1940. In 1909, James Atwood began a new enterprise, initially located in Madison, Wisconsin. By 1910, Atwood had moved Atwood Vacuum Machine Co. to Rockford and joined his brother Seth B. Atwood (in a dark suit, first row, middle) in forming a local vacuum machine enterprise. The impetus for a new invention for the company came when a rattling door in Seth Atwood's car led to the development of an adjustable door bumper in 1915. (Courtesy of Rockford Public Library.)

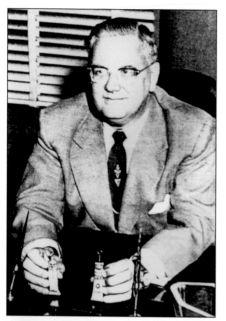

NELS F. TESTOR. Back in 1929, Nils F. Testor, a young Swedish immigrant, purchased the assets of a small Rockford company making an adhesive product called Karlson's Klister. Klister was an adhesive made for mending women's stockings. Testor recognized the need for this kind of adhesive, stepped in, and took over what was soon to become the Testor Chemical Company. As the glue became more popular, other applications were developed, and this product was discovered to be useful and marketed as Crystal Clear Household Cement. The household cement was—and still is—used to mend china, glassware, leather goods, and any number of common household products. (Courtesy of Midway Village Museum, Jon Lundin Collection.)

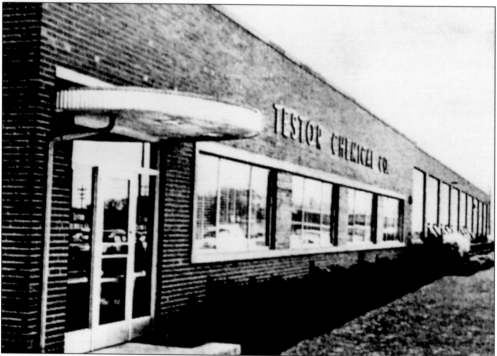

THE TESTOR CHEMICAL CORPORATION. Since the 1930s, the Testor Corporation has been manufacturing products for hobby, craft, and home decorating. When the company produced its first new toy gliders, they became an overnight success. For a number of years, Testor was the single largest user of balsawood in the world. In addition to using balsa for toy planes, Testor also imported the wood for custom model builders. Testor balsa airplanes, plastic model kits, and craft paints and supplies are sold worldwide—satisfying the demand for these fine products. (Courtesy of Midway Village Museum, Jon Lundin Collection.)

Ten

DOWNTOWN AND AROUND
IN ROCKFORD

Horace Greeley, the New York newspaper editor, once said about the Rock River: "I give you fair warning. I take a backseat no longer when the Eden-like character of the Rock River is talked about, for I have been on the Rock River." However, in 1949, *Life* magazine described Rockford as "nearly typical as any city can be."

From 1870 to 1989, a large portion of the earnings in Winnebago County came from manufacturing. In the 1970s, of every 100 workers, 44 held jobs in manufacturing, exactly double the national average. Rockford's 20th-century industry revolved around machine tools, heavy machinery, automotive, aerospace, fastener and cabinet hardware products, and packaging devices and concepts. The city's industrial background has produced many important and interesting inventions, among them the Nelson knitting machine, airbrush, electric brake, electric garage-door opener, dollar bill changer, and electronic dartboard. Such economic progress naturally inspired commercial development of shopping areas, and the land around Rockford changed from rural to residential.

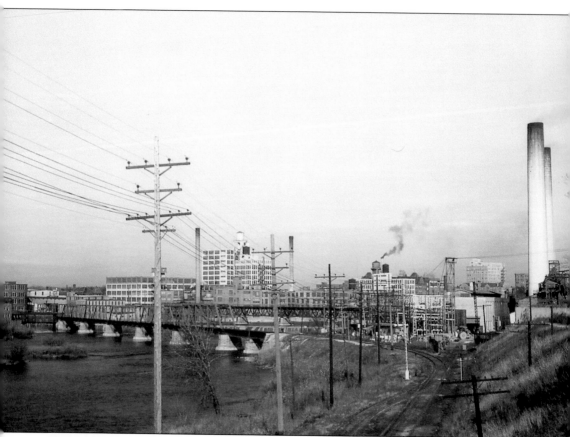

ROCKFORD INDUSTRIAL DOWNTOWN, 1950s. This photograph was taken from the edge of the old Rockford College campus downtown. At the far right of the river is the former Waterpower District, with Amerock's Ziock Building and the Davis industrial buildings in the center and the twin smokestacks of the Fordham power plant on the right. (Courtesy of Bob Anderson.)

Looking East from Courthouse. This 1948 scene from the courthouse sidewalk shows many lawyer's offices on the second and third floors of the buildings on the left side of the street. A popular dining spot for lawyers, Tuckwood's Restaurant, was at 417 West State Street. Other businesses included Hotel Decker, Stern's Pawn Shop, Salamone and Sons Meat Market, McDonald's Birdland, and Forest City Bank. (Courtesy of Bob Anderson.)

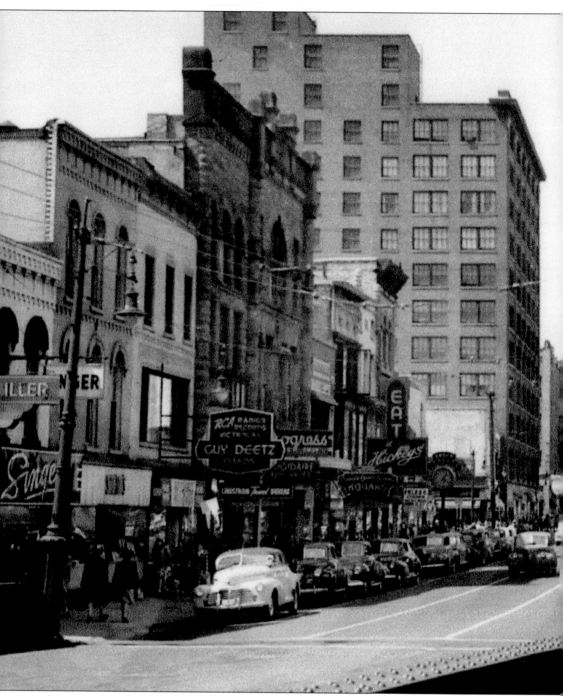

State Street Bridge, 1947. The center of the Rockford commercial district featured Singer Sewing Store, Nelson Shoes, Haddorff Music House, Lindstrom Travel, Camera Craft, Owens Department Store, Hickey's Restaurant, and Anger's Jewelers on the left side of the street and Ritz Hat Shop, Ruth's Donuts, and the State Theater on the right. The 100 block included restaurants, two theaters, two jewelers, a furrier, clothing and dry goods stores, the Temperance Union headquarters, and the office of the *Rockford Register*. In the 1890s, State Street was paved

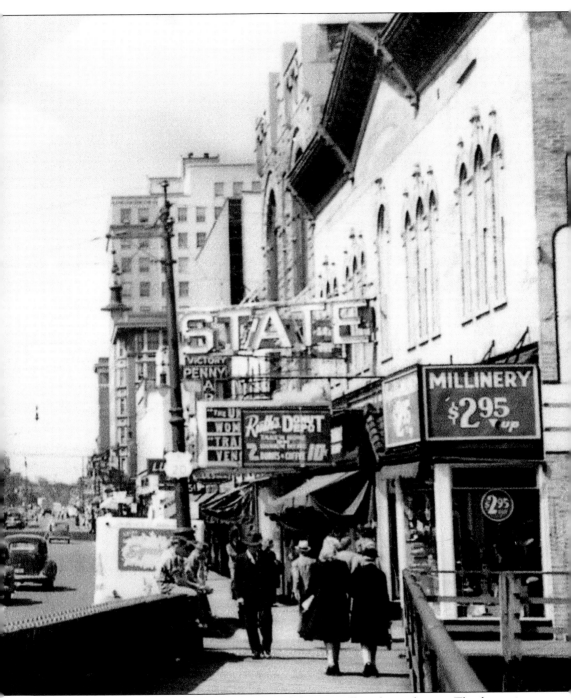

with bricks for the bicycles, horses and buggies, and electric trolleys that rode on it. The dramatic shift caused by the advent of the automobile is seen in this 1947 photograph, by which time the horses and trolleys were long gone. State Street was still the center of Rockford shopping at the time; it was not until the 1980s that Rockford shoppers abandoned its central downtown shopping area for suburban shopping malls. (Courtesy of Bob Anderson.)

ILLINOIS CENTRAL PASSENGER STATION, 1949. Passenger trains left Rockford in the morning and arrived in Chicago, allowing riders to shop at Chicago stores like Marshall Field's and catch an evening train back. Both diesel and steam trains served Rockford in the 1930s and 1940s. The Cole Circus train has stopped in Rockford on this morning in 1949. (Courtesy of Guy Fiorenza.)

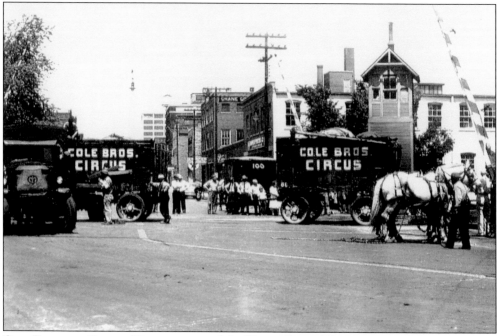

COLE BROTHERS CIRCUS. Circus trains used the Illinois Central Depot to unload the entire circus at South Main Street one morning in 1947. Here, draft horses are being hooked to circus wagons for a parade to the circus grounds. (Courtesy of Guy Fiorenza.)

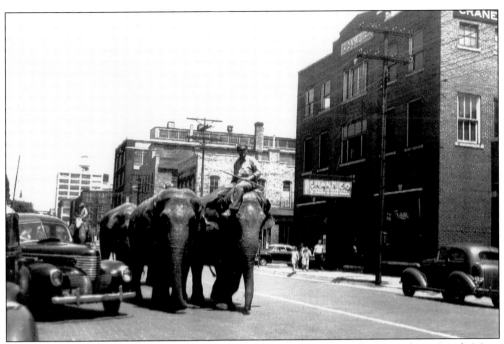

ELEPHANTS MOVE CIRCUS EQUIPMENT. Circus elephants and camels move along South Main Street in this parade. The parade route took the circus along South Main Street to the Fifteenth Avenue Bridge past Blackhawk Park. (Courtesy of Guy Fiorenza.)

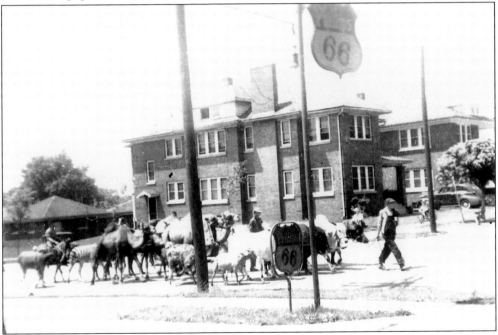

COLE BROTHERS CIRCUS, FIFTEENTH AVENUE. A menagerie of cattle, goats, camels, donkeys, and zebras moves along Fifteenth Street to Seminary Street near the old Beyer Stadium. The circus played in a large field behind the stadium, which was known in the 1940s and 1950s as the Eighteenth Avenue Parade Grounds. (Courtesy of Guy Fiorenza.)

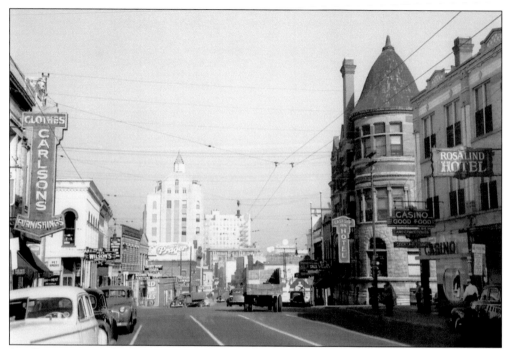

300 Block, East State Street. Carlson's Men's Clothing store and State Recreation Billiards are on the left of East State Street in this image. On the far side of Madison Street intersection near the dump truck are the East Side Inn on the right and Wilson's Pet and Hobby on the left. The Register Star Tower dominates the background, with the State Street Bridge and the downtown area also in the background. (Courtesy of Bob Anderson.)

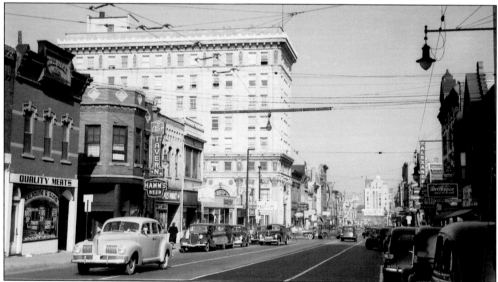

500 Block, East State Street. This 1950 photograph shows Rockford City Hall at center left. On the left side of the street are Salamone Quality Meats, the Office Tavern, the People's Market, and the C&M Restaurant. The right side features the National Tea Grocery, Lawson Paint Company, the Tasty Food Shop grocery, and the Hess Brothers Department Store. (Courtesy of Bob Anderson.)

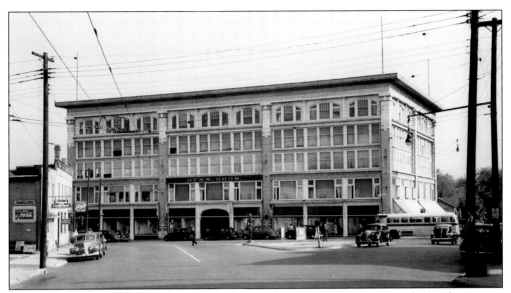

HESS BROTHERS, 1946. In 1910, brothers Carl and Milton Hess and P.A. Peterson built a department store at 516–528 East State Street. It was one of the largest dry goods stores in Illinois when completed. Peterson bought out the Hess brothers and became sole owner of the department store on State Street at the Kishwaukee Triangle soon after its opening. It is said he acquired the store to give his wife something to do. Many thought the building's location was bad, because it was far from the downtown, but the store was very successful. Later, Peterson's wife, Ida, actually managed the department store. (Courtesy of Bob Anderson.)

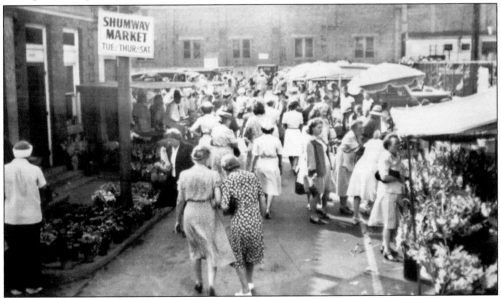

SHUMWAY MARKET, 1947. First established in 1905, the market was a place for farmers to gather and sell their fruits, vegetables, and flowers to local residents. It became a highly visited shopping center at 701 East State Street from the 1910s on. An average day in the 1940s and 1950s would bring 200 sellers and 2,000 customers. The popular attraction of the farmer's market continued into the 2000s on East State Street. In the 1940s and 1950s, most patrons parked on the street and walked to the store of their preference. (Courtesy of Bob Anderson.)

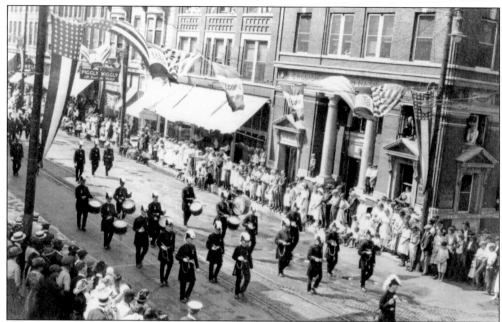

600 Block, Seventh Street. Townspeople line the sidewalks for this Knights of Columbus parade in the 1910s. The Swedish American Bank is across the street, along with the Swedish American Restaurant, Blomgren-Janson Shoes, Pearson and Johnson Meats, the Piggly Wiggly, and the Erickson Home Bakery. (Courtesy of Bob Anderson.)

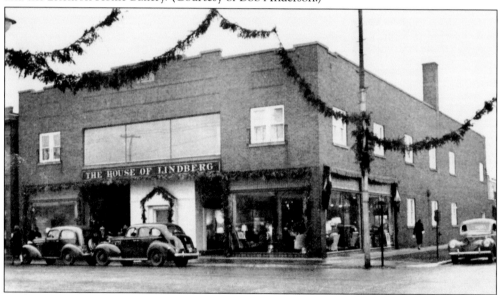

House of Lindberg, Broadway. Broadway (earlier named Fourteenth Avenue) was also a vital shopping district for the many families living in southeast Rockford. The trolley system in the city provided transport for residents visiting the shopping area. On the right in this 1940s image, is the high-end furniture store House of Lindberg, at 1201 Broadway. The same block also featured Corey's Ice Cream Shop, Melen's and Skogsberg's Bakeries, and the Broadway Police Station. Broadway was also home J.C. Penney, a Woolworth five-and-dime, Carl Lindquist Jewelers, the Busy Bee Restaurant, and the Home Shoe Company. (Courtesy of Bob Anderson.)

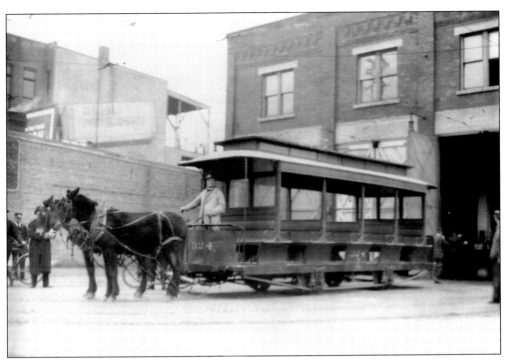

CITY TROLLEY BARN. The trolley system provided Rockford citizens with the means to travel through the city with ease. The system started with horsepower, but ran on electric power in its heyday. As the automobile took over, public transportation switched to a municipal bus system in the same trolley barn, shown above in 1880 and below as the interurban barn in 1924. Today, the barn is the home of Lloyd's Hearing Aid Corporation. (Above, courtesy of Midway Village Museum; below, courtesy of Bob Anderson.)

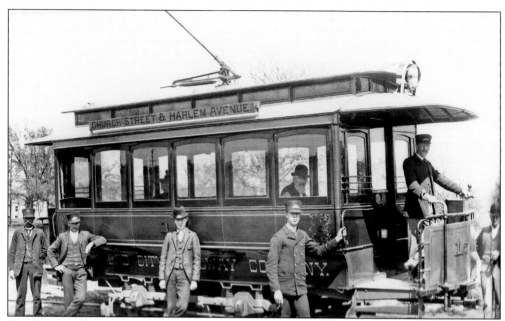

CITY RAILWAY TROLLEY, LATE 1890s. In 1889, Rockford City Railway was rescued from bankruptcy and Judge R.N. Baylies was given control of a rescue plan. Part of his plan was the construction of the Harlem Amusement Park. This trolley was assigned to the Harlem route. In the summer, two or three extra cars were attached. (Courtesy of Midway Village Museum.)

SMITH OIL STATION, 1930s. In 1925, Stanton K. Smith, the third generation of the Smith family, joined the firm and established a service station and distribution system covering northern Illinois, eastern Iowa, and southern Wisconsin. In 1946, Smith Oil entered into an agreement with Gulf Oil Corporation to distribute its products and became the nation's largest independent reseller of Gulf products. (Courtesy of Midway Village Museum.)

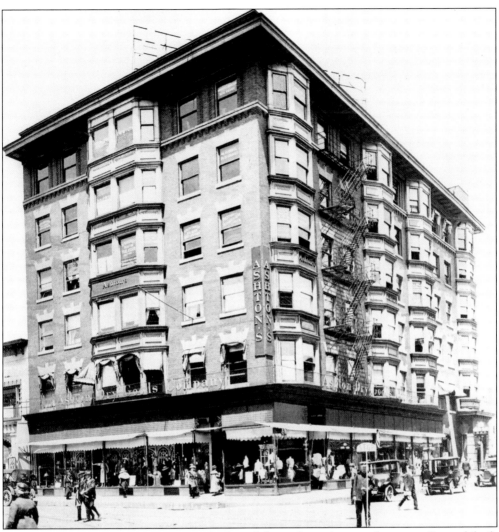

ASHTON'S DEPARTMENT STORE, 1904. Andrew Ashton, formerly a storekeeper in Durand, built Rockford's first "skyscraper" when he erected a new, six-story store at the corner of West State and Main Streets in 1904. It later became known as Rockford Dry Goods, but the structure was torn down in 1984 and replaced by a multi-deck parking lot. (Courtesy of Midway Village Museum.)

CHARLES STREET, 1949. This block of Charles Street featured favorite spots for from Lincoln Junior High students. Next to Hedlin's Pharmacy on the right were a dentist office and a barbershop. On the left were the Arctic, Billstrand's Grocery, a butcher, and Lincoln Bakery. At lunch hour in the 1950s, students swarmed for Arctic burgers and long johns (a chocolate-covered, donut-like pastry) from the Lincoln Bakery. (Courtesy of Bob Anderson.)

SWEDISH AMERICAN HOSPITAL, 1947. The Swedish American Hospital began with a meeting between P.A. Peterson and Levin Faust, who both felt that Swedes in Rockford needed a hospital of their own. The two men began a $175,000 fund drive in 1911 with the help of Rockford's Swedish newspaper, the *Svenska Post*. They raised the necessary funds, and the 55-bed hospital opened in 1918. (Courtesy of Bob Anderson.)

LONGWOOD AND CHARLES STREET, 1949. Dominic Martinetti ran this little family corner grocery at 1102 Charles Street. Today, this intersection is entirely different, with the rear of the U.S. Bank—previously the Home Bank Building—and a Walgreen's in place of the large elms and the small grocery. (Courtesy of Bob Anderson.)

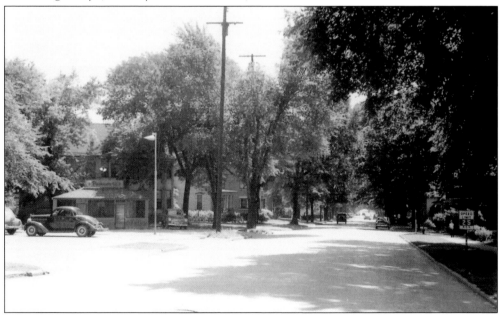

PARKMORE ROOT BEER STAND. The Parkmore Drive-in, at 1212 Charles Street, one block from the Swedish American Hospital, was also a favorite for local teens in the 1940s. Female carhops took orders for root beer floats, hot dogs, burgers, and fries. A root beer was only 5¢, and teens and their dates would pull in after a movie at the State Theater or a high school football game for a "Black Cow." (Courtesy of Bob Anderson.)

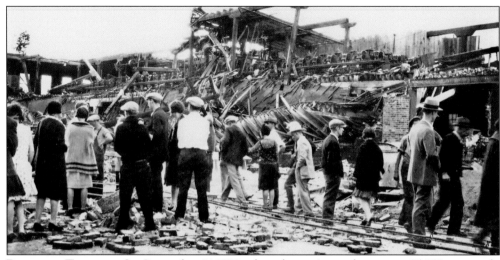

ROCKFORD TORNADO. On September 14, 1928, when the city's population was 85,000, a tornado touched down near the southern city limits. It moved northeastward over the southeastern portion of the city for about 23 miles, ripping through more than 30 city blocks. The Rockford Chair Company (pictured) was almost completely demolished, and debris was scattered over an open field for several hundred yards. News records indicate that 14 were killed and 36 were injured. Four factories and 360 dwellings were demolished. (Courtesy of Midway Village Museum.)

ROCKFORD'S POLIO EPIDEMIC. In July 1945, Rockford was hit with an epidemic of infantile paralysis. In the next few months, 382 people contacted the disease. Of these, 36 died—80 percent of them children. Posted proclamations warned parents to keep any child younger than 14 isolated. Many medical personnel from Camp Grant who had finished their military duty were recruited to help local polio victims. Children were placed in complete isolation in the Winnebago County Hospital, located outside the northern edge of the city. As a five-year-old in the summer of 1945, the author (left) was stricken with polio. Here, he works on a puzzle with another boy, passing many long hours (over one year) in bed in the 10-bed ward. Visiting parents had to place a ladder outside the second floor of the hospital and view their children through closed windows. (Courtesy of *Register Star*.)

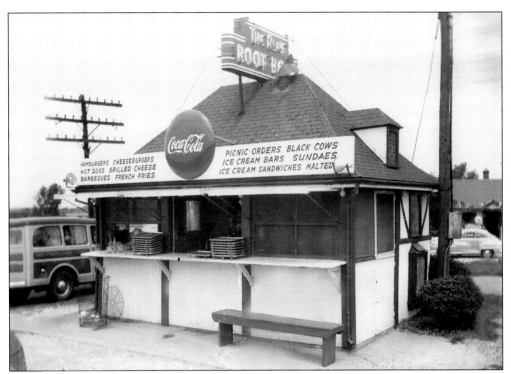

ALPS DRIVE-IN, 1949. On summer evenings in the 1940s and 1950s, the Alps parking lot was always mobbed by families and groups of teens in their cars who had come for a root beer treat. At the time of this photograph, the Alps was located at the edge of the city. A few years later, this intersection—State Street and Alpine Road—would become the busiest in the city. (Courtesy of Bob Anderson.)

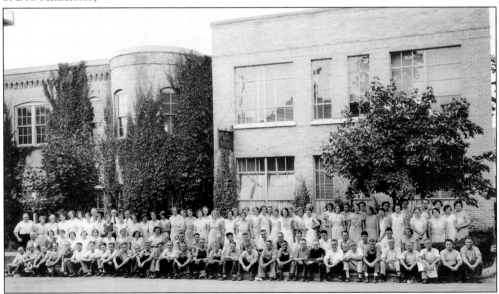

FOREST CITY KNITTING EMPLOYEES, 1936. The entire workforce of the Forest City Knitting Company poses for this photograph in 1936. John Nelson's sons, Frithiof and William, continued the company, which was known for its fine-quality cotton socks for adults. (Courtesy of Bob Anderson.)

HALLSTROM SCHOOL KINDERGARTEN CLASS. Myrtle Rosene teaches kindergartners at Hallstrom School in the 1930s. Rosene's was one of Rockford's outstanding activity-based kindergartens up until the 1970s. (Courtesy of Gloria Meli.)

WIGHT SCHOOL CLASS. In the 1960s, Caroline Swanson (right) followed Myrtle Rosene in the kindergarten room at Hallstrom. In the 1980s, Swanson, with her helper, Bonnie Cyprus (left), taught a much smaller class at Wight School in Rockford. (Author's collection.)

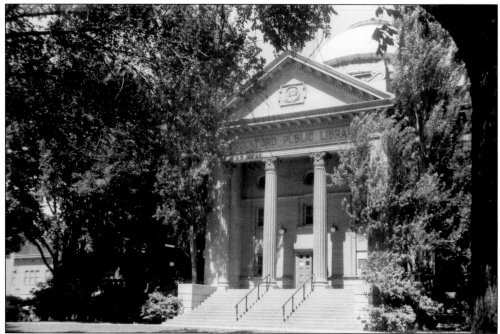

ROCKFORD PUBLIC LIBRARY. On June 17, 1872, the Rockford Public Library was organized. Reading rooms opened in August of that year on the second floor of a building at the corner of State and Main Streets. In 1901, Andrew Carnegie gave a personal grant of $70,000 to build this main library, which opened to the public and was dedicated in November 1902. (Courtesy of Bob Anderson.)

HIGHLAND SCHOOL, 1949. Highland School was one of Rockford's premier grade schools but was closed in the mid-1970s as an austerity measure by the Rockford Board of Education. (Courtesy of Bob Anderson.)

Eleven

A PLACE FOR
ROCKFORD HISTORY

Midway Village Museum was organized in 1968 by the Swedish, Harlem, and Rockford Historical Societies for the purpose of collecting, preserving, and interpreting the history of the Rockford area. In 1972, the original museum site was on 11 acres donated by the Severin family; today, the site covers 137 acres. The programs at the museum are all intended to make history come alive for children and adults. The village and the museum also serve as a living laboratory of history for teachers and students.

The development of Midway Village began in 1974, and it illustrates a typical rural town in northern Illinois at the end of the 19th and the beginning of the 20th centuries. Midway Village features 26 historical structures, including a general store, hardware store, print shop, blacksmith shop, schoolhouse, town hall, police station, plumbing shop, bank, hotel, hospital, fire station, church, barbershop, law office, two barns, and four farmhouses.

Midway Village Museum offers a variety of programs and events for all ages, covering the time from early pioneer settlement through World War II. Programs include Victorian teas, a *Titanic*-themed supper, Civil War Days, and Rockford Pioneer Days. Interpreters in authentic period clothing bring history to life and engage students through a variety of hands-on activities—a day in a one-room school, rope-making, blacksmithing, and operating an 1890s printing press

The original Museum Center facility also opened in 1974, and the Industrial Gallery opened in 1976. In 1986, the Exhibition Hall was constructed to link the previous two buildings together. In 1988, more galleries were opened, including the Old Dolls' House Museum, the Aviation Gallery, and the Carlson Education Gallery. Today, the 52,700-square-foot Museum Center houses seven exhibition galleries, collections storage, classrooms, workrooms, administrative offices, a library, an audiovisual room, and the museum store. An exciting new exhibit featuring the immigrants who came to Rockford opened in 2012.

LAKE SEVERIN AND THE MILLHOUSE. The Old Millhouse, on the edge of the museum's Severin Lake, is a working replica of an early Rockford water-powered machine shop. Power is supplied by electric pumps delivering water to the sluice. For the actual shop machinery, everything is powered by water, just as it was in Rockford's early days. (Courtesy of Midway Village Museum.)

SOCK-MONKEY MADNESS AT MIDWAY. These stuffed animals are made from the red-heeled socks John and William Nelson and the sock-knitting industry played such an important role in creating from the 1870s all the way through the 1990s. In the fall, the Sock Monkey Madness event in Midway Village is filled with creatures, both knit and fiberglass, decked out in all sorts of costumes. (Courtesy of Midway Village Museum.)

MARSH HOUSE AND THE 1905 RED BARN. Russell and Abigail Marsh originally homesteaded and built a log cabin on the Guilford Road farm in 1838. The Greek Revival–style house to the left was erected by one of the Marshes' sons, George, in the early 1860s. It was moved Midway Village in 1989. The 1905 Red Barn was originally built as a dairy barn and later used for storage and hay. It is a pegged barn, but the timbers were sawn at an area sawmill. (Author's collection.)

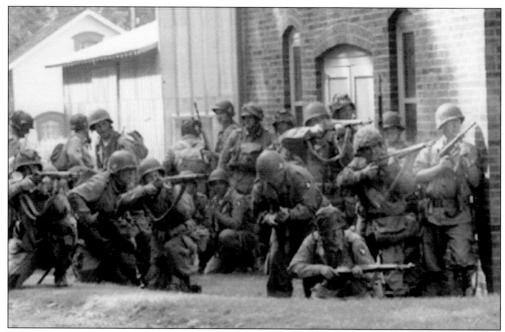

WORLD WAR II DAYS AT MIDWAY. Each fall, Midway Village holds a World War II event, which often includes over 1,000 reenactors from different states representing soldiers from Allied countries, as well as Japan, Italy, and Germany, along with a variety of vintage tanks, half-tracks, and other 1940s-era vehicles. (Courtesy of Midway Village Museum.)

BERT HASSELL'S ROCKFORD-TO-STOCKHOLM PLANE. The interactive flight exhibit in the Midway Village Museum teaches people about Rockford's pioneer aviators, including Col. Bert Hassell and Bessica Raische. Hassell's 1928 attempt to be the first to fly a great-circle route to Europe in his plane *Greater Rockford* is chronicled. (Courtesy of Midway Village Museum.)

MIDWAY'S SCARECROW FESTIVAL. At the Scarecrow Festival, families enjoy the tradition of making their own scarecrows to take home for autumn decorations. Midway Village provides the straw for free, and families can make as many scarecrows as they can carry. Folks also explore demonstrations of rare antique threshing and baling machinery provided by village blacksmith reenactors. (Courtesy of Midway Village Museum.)

THE CARLSON-ROSS GENERAL STORE. Built in 1988, this full-scale 1880s facsimile of Rockford's early general stores in the late 1830s and early 1840s features china, cigars, coffee, and clothing—the typical goods sold at the time. In the rear of the general store is a local post office with letter drop-off and delivery. (Courtesy of Midway Village Museum.)

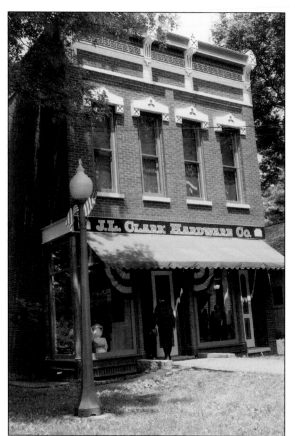

J.L. CLARK HARDWARE STORE.
J.L. Clark invented the Gem Flue
Stopper for potbellied stoves. From
this product, he and his son built
a large corporation in Rockford.
When Clark first came to Rockford,
he opened the J.L. Clark Hardware
Store, seen here in this 3/4-scale
reproduction built in 1989. Upstairs,
an exhibit explores the Clark family,
their inventions, and the company
they founded. (Author's collection.)

CHAMBERLAIN HOTEL. The original
Chamberlain Hotel served the crews
and passengers of the 60 trains
passing daily through Caledonia.
Originally known as the Montayne
House, it became the Chamberlain
Hotel in 1878 when Catherine
Chamberlain acquired the property.
The front doors, parlor doors,
staircase spindles, and newel post
in this 1984 re-creation most likely
are from the original Chamberlain
Hotel. (Author's collection.)

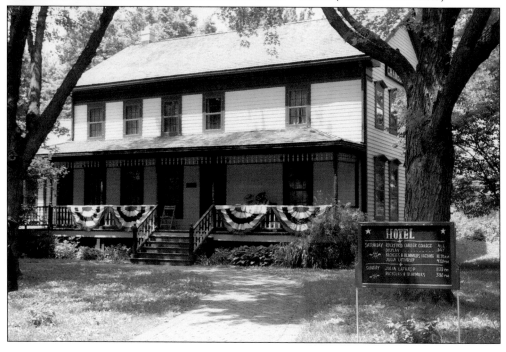

ROCKFORD GAZETTE BUILDING.
This redbrick building reproduction
of the original 1880s Gazette
Building on State Street on the
west side of town was built in 1989.
On special event days, reenactors
demonstrate how the flatbed printer
works. (Author's collection.)

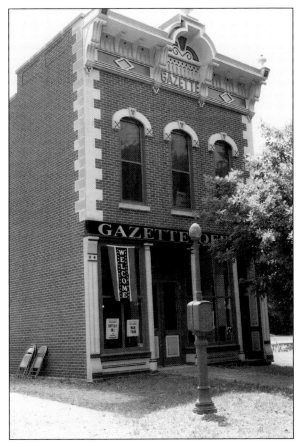

BLACKSMITH SHOP. One of
the first buildings in Midway
Village in 1974 was this full-scale
re-creation of a typical blacksmith
shop around 1900. Blacksmiths
often demonstrate techniques for
visitors. (Author's collection.)

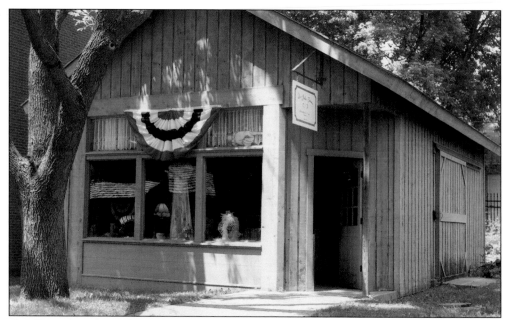

THE PLUMBING SHOP. This full-scale reconstruction, built in 1981, takes after a 1900s-era shop and shows how indoor plumbing was first introduced to Rockford in 1875. Plumbing shops like this one sold the latest conveniences, including elaborate toilets, bathtubs, and decorative plumbing fixtures. For the Chautauqua event, this building served as a millinery and dry goods shop. (Author's collection.)

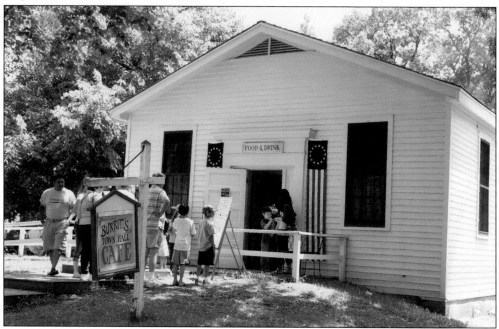

TOWN HALL. This town hall originally stood in Harlem Village and is similar to many town halls built in rural Illinois for local governmental meetings, elections, social gatherings, penny potluck suppers, dances, and receptions. It was one of Midway Village's first buildings, ready for the 1974 opening. For the Chautauqua event, this building served as a village café. (Author's collection.)

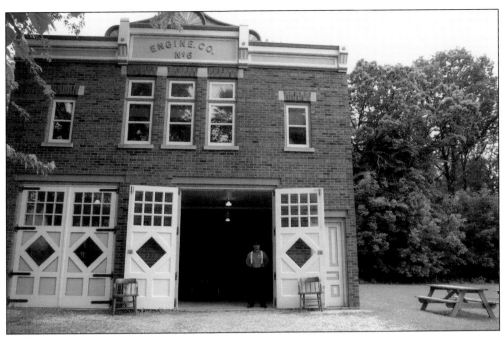

MIDWAY VILLAGE FIRE STATION. This replica firehouse, furnished with firefighting equipment from the late 1800s, is a 3/4-scale replica of Rockford's Fire Station No. 6 built in 1907. It was constructed and furnished in 1995 with the help of the Rockford Fire Department. Fire personnel also perform as reenactors at many special events. (Author's collection.)

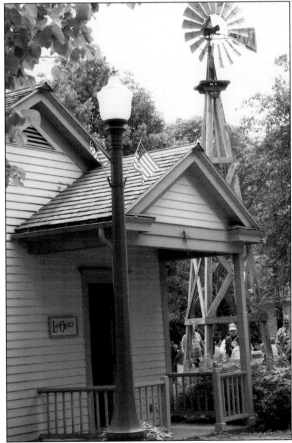

MIDWAY VILLAGE LAW OFFICE AND WINDMILL. The law office at Midway was built in 1979 and recreates a 1900s-era small-town law office. Furnished by Rockford lawyers and their wives, its exhibits include a document press, a rolltop desk, and a collection of authentic law books that could be found in a lawyer's office in the late 1800s. (Author's collection.)

DR. BALTHASAR, PATENT MEDICINE HAWKER. While most reenactors at Chautauqua events are volunteers, some, like Dr. Balthasar, patent medicine hawker, are recruited for their acting talent and are paid. These actors make the Chautauqua event more authentic and often demonstrate in detail and involve the audience in the scene. (Author's collection.)

ANNIE OAKLEY AT CHAUTAUQUA. This Shooting Gallery Booth is an added feature to many of Midway Village Museum's outdoor events in the summer. Chautauqua events attempt to replicate the past events held at Harlem Park from 1902 into the 1920s. (Author's collection.)

BUFFALO BILL'S WILD WEST SHOW. To add further ambiance to the Chautauqua event, Midway Village Museum has added Buffalo Bill's Wild West Show. When Rockford held Chautauqua events, over 80,000 people attended annually, and Buffalo Bill's real Wild West Show appeared in Rockford on August 28, 1896, at Fairgrounds Park. (Author's collection.)

CHAUTAUQUA RE-CREATED. The annual 1900 Chautauqua event at Midway Village Museum offers two days of rich entertainment and interactive history programs for visitors of all ages. The photograph shows some "sutlers who followed Buffalo Bill's Wild West Show" and help the event seem real. Chautauqua 1900 emphasizes the culture and famous people of the year 1900 in a Victorian-era living history village of 26 buildings. New and different speakers, programs, and special exhibits are offered for Chautauqua 1900 each year. (Author's collection.)

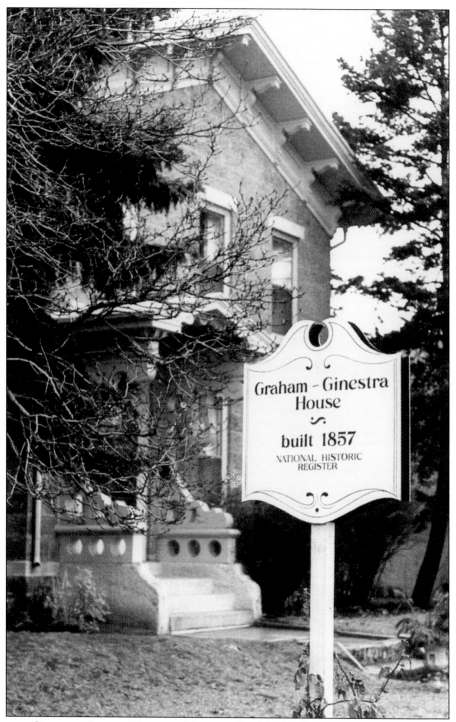

GRAHAM-GINESTRA ETHNIC HERITAGE MUSEUM. Rockford is fortunate to have three museums devoted to preserving Rockford history. The Graham-Ginestra Ethnic Heritage Museum is in an 1852 home and has six galleries, representing the ethnic groups that settled in southwest Rockford: Italians, African Americans, Irish, Hispanics, Lithuanians, and Poles. (Author's collection.)

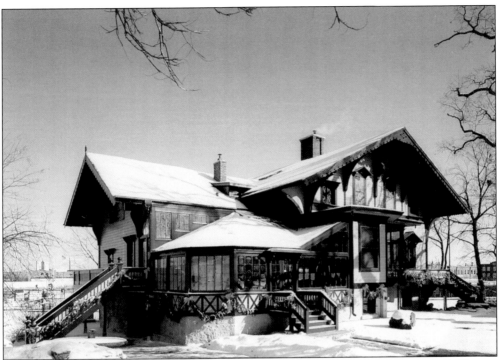

TINKER COTTAGE. Robert Tinker built this home overlooking Kent Creek in 1865. He was inspired to build the unique house after an 1862 tour of Europe, when he and his wife fell in love with Swiss architecture. Today, Tinker Cottage is a museum and one of only a handful of 1800s Swiss-style homes remaining in America. (Author's collection.)

NICHOLAS CONSERVATORY. The Rockford Park District opened an exciting new museum facility in Sinnissippi Park Gardens in 2012. The new conservatory is a plant exhibition center that provides a place where the public can learn about the world of plants and the important role they play in human lives. The facility is a year-round exhibit space of tropical trees, plants, and flowers. The new building is the third-largest conservatory in Illinois. The outside areas around the conservatory, including an updated lagoon, are attractively landscaped in a natural setting. (Author's collection.)

DISCOVER THOUSANDS OF LOCAL HISTORY BOOKS FEATURING MILLIONS OF VINTAGE IMAGES

Arcadia Publishing, the leading local history publisher in the United States, is committed to making history accessible and meaningful through publishing books that celebrate and preserve the heritage of America's people and places.

Find more books like this at
www.arcadiapublishing.com

Search for your hometown history, your old stomping grounds, and even your favorite sports team.